IMAGES
of America

NORTHPORT

IMAGES
of America

NORTHPORT

Teresa Reid and Robert C. Hughes

ARCADIA
PUBLISHING

Published by Arcadia Publishing
Charleston, South Carolina

Printed in the United States of America

Library of Congress Control Number: 2018932621

For all general information, please contact Arcadia Publishing:
Telephone 843-853-2070
Fax 843-853-0044
E-mail sales@arcadiapublishing.com
For customer service and orders:
Toll-Free 1-888-313-2665

Visit us on the Internet at www.arcadiapublishing.com

*To Andy, for bringing me home to Northport, and
to Kelsey, who inspires me every day*

To the little red-haired girl

CONTENTS

ACKNOWLEDGMENTS

Like Northport itself, this book would not have been possible if not for the hard work, dedication, and generosity of those who came before us. The images captured by the early photography work of W.B. Warner, Frank Yamaki, Judson Snyder, and Jack Blydenburg were invaluable to the creation of this book and will serve generations to come. We owe a debt of gratitude to past historians and writers such as Cynthia Quackenbush Hendrie, Fred Black, George Wallace, Edward Carr, Dick Simpson, Barbara Johnson, and Thelma Jackson, all of whose research has preserved and taught Northport's history. We also extend a very special thank-you to Village of Northport historian Steven King for his knowledge and guidance, which have proved invaluable in completing this book.

The Northport Historical Society (NHS), director Tracy Pfaff, assistant director Kathy Fitzpatrick, and the board of trustees must be thanked for all their support in the making of this book as well as all the hard work they do to further the society's mission.

We would also like to acknowledge the following people who helped by sharing their time, resources, and knowledge: Mayor George Doll; Frank and Steven Cavagnaro; Huntington Historical Society archivist Karen Martin; Lauren Brincat, curator of Preservation Long Island; Tori Lima; and Joe Schmitz.

In addition to providing seemingly limitless research resources for preparing the narrative, the Northport Historical Society's carefully curated collection served as the primary image source for this work; unless otherwise noted, all images are used with the society's permission. All authors' royalties for this work have been donated to the NHS to benefit preservation efforts in the community. For those interested in contributing to the archives at the NHS, joining the organization, or seeking permission to utilize its collection for personal or commercial use, please contact info@northporthistorical.org or access the society's website at northporthistorical.org.

INTRODUCTION

English settlers first arrived on Long Island's north shore in the mid-17th century. The first purchase of land from the native inhabitants in what is now the town of Huntington was made in 1653. Three years later, the Second, or Eastern, Purchase was made. The Eastern Purchase, which includes the area now known as Northport, encompassed land from the head of Northport Harbor to the Nissequogue River.

A subsequent deed to Richard Smith from the Nissequogue Indians covered much of the same territory. In order to solidify its claim to the disputed land, Huntington laid out the so-called Ten Farms and encouraged settlers to move to these farms, which were along the shoreline from Crab Meadow to the Nissequogue River. Only a few settlers took advantage of the opportunity, and eventually, the disputed territory was divided between Huntington and Smithtown.

The first area of settlement on the Huntington side of the boundary line was in the area known as Red Hook, centered on the present-day intersection of Route 25A and Waterside Avenue. A few pioneers, including Ebenezer Bryant, settled near the harbor, then known as Great Cow Harbor. In 1790, the path through the woods from Red Hook to Bryant's farm near the harbor was replaced by a 50-foot-wide dirt road, which came to be known as Bryant's Landing and is now known as Main Street. The road provided access to the harbor for the shipment of cordwood, which was the area's first export product.

In 1802, twenty-eight residents petitioned the Town of Huntington for permission to build a dock at Bryant's Landing. Other docks followed, and during the early 19th century, the focus of activity moved from Red Hook to the harbor. The name of the area was officially changed to Northport in 1837.

Throughout the 19th century, shipbuilding was a mainstay of the local economy. The shipyards along Bayview Avenue constructed hundreds of ships until the end of the sailing era. Northport boasted at least four shipyards, employing over 100 men and launching around 258 vessels.

Fortunes were also made by planting and harvesting oysters, which were shipped to dinner tables far and wide. The men who grew wealthy from the oyster trade used their money to create the Northport we know today. They established groundbreaking legal publishing companies, led the call for village incorporation, and helped create the fire department, the electric company, and the water company. They developed the commercial section of the village as well as residential neighborhoods that are among the prettiest on Long Island.

The natural environment on land also provided a source of income for many. Sand and gravel mining altered the topography of the area while furnishing the raw material to build New York City. Likewise, local clay was used to produce millions of bricks.

The loss of the Edward Thompson Company, publisher of law books, in the midst of the Great Depression had a devastating effect on the village. But the post–World War II population boom helped the village grow to unprecedented levels. Still, the downtown business district suffered. In the 1960s, plans were developed that would have destroyed the historic character of the village

by demolishing proud 19th-century buildings and replacing them with parking lots. Fortunately, those plans were never realized, and the village came through the stagnation of the 1970s with its history more or less intact.

In more recent years, Northport has enjoyed a renaissance as new businesses, boutiques, restaurants, and microbreweries fill its historic buildings. The effort is best reflected in the emergence of the Engeman Theater as a cultural magnet for visitors from throughout Long Island.

Time and again, the people of Northport have supported each other whenever there was a need, offering their money, skills, and friendship. Northport retains its small-town character thanks to that community spirit and its rich history, making it one of the most successful villages on Long Island.

One

EARLY HISTORY AND FOUNDING FAMILIES

On July 30, 1656, Jonas Wood, William Rogers, and Thomas Wilkes negotiated the Second, or Eastern, Purchase with Sachem Asharoken. This extended the land holdings Huntington settlers had purchased three years earlier to include land from Northport Harbor to the Nissequogue River. Under this deed, the Matinecocks reserved the right to hunt and plant on the land and were given "two coats, four shirts, seven quarts of licker and eleven ounces of powther."

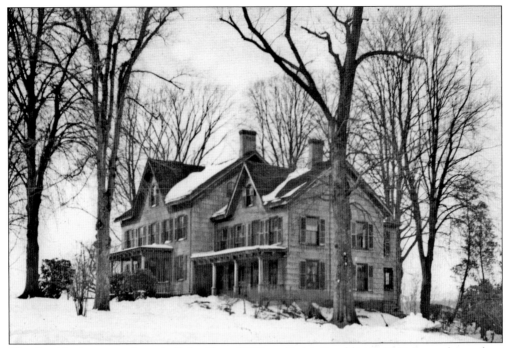

The Scudder homestead was built by Capt. William Smith Scudder in 1767. It was located on Route 25A at the head of Northport Harbor. He was a descendant of Thomas Scudder, one of the founders of the town of Huntington. Captain Scudder was a sea captain during the Revolutionary War who ran scouting missions on the sound. Despite the Northport Historical Society's efforts to save it, the house was razed in 1969.

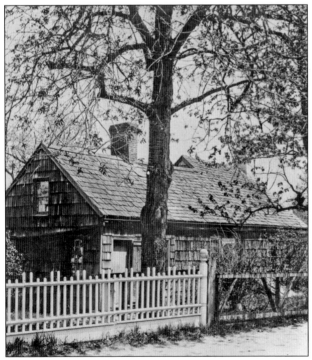

Bryant Skidmore built this farmhouse in 1761, when the area was called Great Cow Harbor. This settlement stretched from the harbor to the area formerly known as Red Hook, at the corners of Vernon Valley Road, Waterside Avenue, Route 25A, and Main Street. The Skidmore home still stands today at 529 Main Street and is Northport's oldest surviving house.

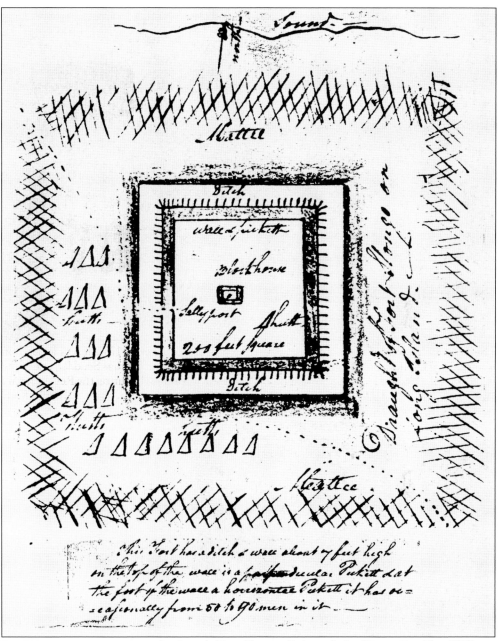

During a spying mission on the British Fort Slongo (Salonga), Lt. Henry Scudder (William Scudder's second cousin) and Bryant Skidmore drew this diagram and sent it to the commander of the American forces. On October 3, 1781, utilizing this map, American forces from Connecticut launched an attack on the fort, resulting in a victory for the Continental army. Wounded during the battle, Sgt. Elijah Churchill became the first person ever awarded the Purple Heart. After the war, Lieutenant Scudder became a member of the convention that framed the New York State Constitution. He died in 1822 and is buried in Old Northport Burying Ground on Route 25A, not far from the original site of the Scudder homestead.

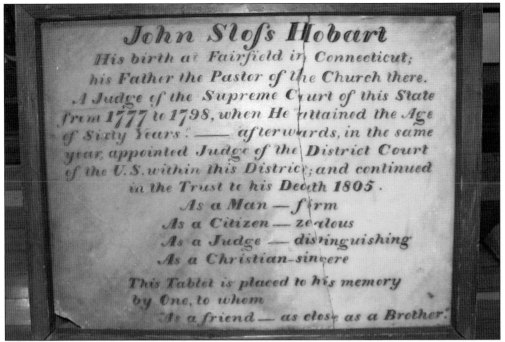

John Sloss Hobart

His birth at Fairfield in Connecticut;
his Father the Pastor of the Church there.
A Judge of the Supreme Court of this State
from 1777 to 1798, when He attained the Age
of Sixty Years: ____ afterwards, in the same
year, appointed Judge of the District Court
of the U.S. within this District; and continued
in the Trust to his Death 1805.
As a Man — firm
As a Citizen — zealous
As a Judge — distinguishing
As a Christian-sincere

This Tablet is placed to his memory
by One, to whom
As a friend — as close as a Brother.

John Sloss Hobart (1738–1805) inherited Eaton's Neck from his grandfather. When the Revolutionary War broke out, he financed and led the underground resistance during British occupation. He was elected as a delegate to the Provincial Congress, which approved the Declaration of Independence. Hobart served on the New York State Supreme Court and, as a US senator, he introduced the bill that authorized the construction of the Eaton's Neck Lighthouse. In the 1950s, the town beach on Eaton's Neck was named Hobart Beach in his honor.

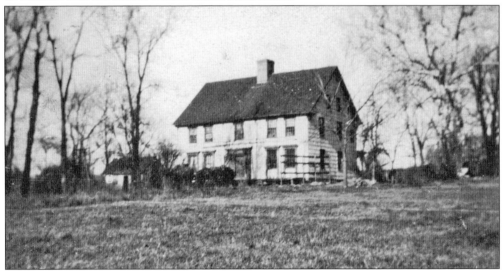

Hobart and his wife, Mary Grinnell, lived on Eaton's Neck on an estate known as Cherry Lawn. The house was located between what is now Cherry Lawn Lane and Northport Bay. Left broke after the war, Hobart was forced to sell Eaton's Neck. The last owners of the house, the Rowland family, moved out around 1920. The house was left vacant, succumbing to vandalism and the elements until nothing was left of it by the mid-1930s. (Courtesy of Edward Carr.)

On June 16, 1798, the federal government bought 10 acres of land for the sum of $500 from the owners of Eaton's Neck, John and Johanna Gardiner, to construct a lighthouse to warn of the dangerous reef of rocks nearby. John J. McComb Jr. prepared these architectural drawings. Construction began later that year. The lens was manufactured by the Henry Lepaute Company and shipped from Paris, France. Four whale-oil lamps were mounted in the center of the lens to cast the light.

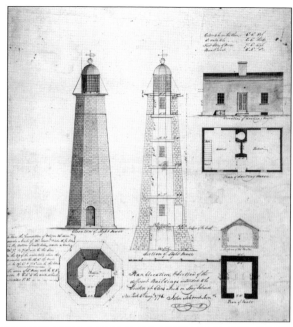

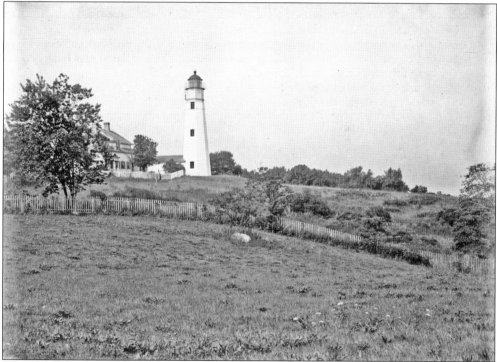

In the spring of 1799, the beacon was lit, and the 19-year-old son of the Gardiners, John H. Gardiner, became the first keeper of the light. His job was to refill and light the whale-oil lamps each night and keep an eye out for vessels in peril. In 1921, the Long Island Lighting Company extended electric lines all the way to the lighthouse, and the beacon was electrified. The Eaton's Neck Lighthouse is the second-oldest on Long Island, after Montauk. It was added to the National Register of Historic Places in 1973.

Whereas it will be of public utility to erect a Dock at the place called Bryan's landing as it may promote navigation and commerce and thereby encourage Agriculture. —

And whereas for the accomplishment of said object a company is formed to be called and known by the name of "the directors and company of the Dock at Bryan's landing." That the capital stock of the said company shall consist of one hundred shares. And that subscriptions for shares in said company shall be taken by the persons, not more than five nor less than three who may be chosen directors in the following words: We whose names are hereunto subscribed, do for ourselves and for our legal representatives promise to pay unto the directors and company of the Dock at Bryan's landing such sums of money for each share (which we or our legal representatives shall from time to time hold in the same) and in such proportions and at such time and times as the directors shall direct and require. And the said board of directors shall immediately after the company be constituted and their elect open a book for listing in subscriptions for the purposes aforesaid in the form aforesaid — Provided always that every subscriber shall at the time of subscri or within twenty days after pay into the hands

By the end of the 1700s, Great Cow Harbor was home to 31 families. Farming was the major livelihood, but the sale of cordwood turned a good profit. In 1790, a path was laid out to the harbor, passing through Ebenezer Bryant's property. Residents piled their cordwood at the foot of the harbor while awaiting shipment. In 1802, twenty-eight residents formed the Bryant's Landing Dock Company. A dock was built where the village dock stands today.

Two

SHIPS AND SAILORS

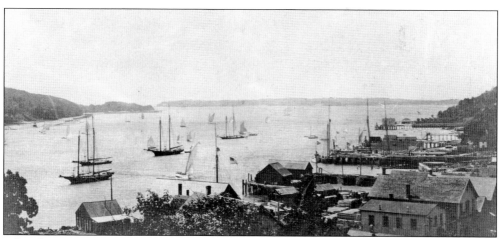

After the War of 1812, Long Island saw an increase in maritime vocations such as whaling, shell fishing, and overseas trade. Northport's naturally deep harbor made it the perfect location to engage in these activities. Many sea captains, sailors, and shipbuilders made their homes and businesses along Bayview and Woodbine Avenues. The period between 1840 and 1890 saw the biggest boom in shipbuilding, with Northport boasting at least four shipyards, employing over 100 men and launching around 258 vessels.

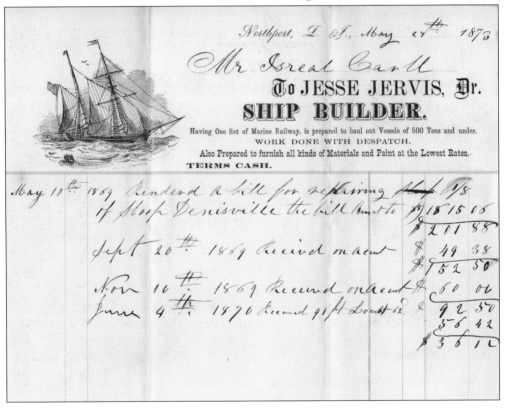

Jesse Jarvis (1814–1890) began building ships around 1841 along Woodbine Avenue. He is credited with building 35 ships throughout his 40-year-plus career. In an article published in the *Brooklyn Eagle*, Jarvis was described as "a shrewd ship builder, a rich man, and, in all points, the leading man in town." Jarvis was a leader of the popular Spiritualist movement. Under Jarvis's influence, many carpenters, captains, and sailors became Spiritualists until the movement died out soon after his death in 1890.

This receipt dated in 1870 is for work to replane the sloop *Denisville*, owned by Israel Carll, which he paid off in installments. Workers at the Jarvis shipyard earned between $4 and $4.50 for a 10-hour workday that began at seven in the morning and ended at six in the evening.

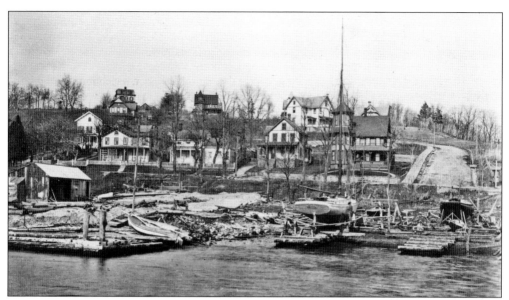

Started by Samuel Prior Hartt in the 1820s, the Hartt family shipyard, seen here, was a family affair that included his brother Moses, his son Erastus, and his grandson Oliver. It was located along the waterfront of Bayview Avenue. The Hartts lived at 12 Bayview Avenue, seen below. Originally built in the 1820s by Jesse Bunce, the house and its property of 80 acres stretching up the hill were sold to Hartt in 1836. He doubled its size and turned it to face the harbor. The Hartts often hosted celebratory parties here after the launching of a new ship. It still stands today as one of the oldest houses on Bayview Avenue.

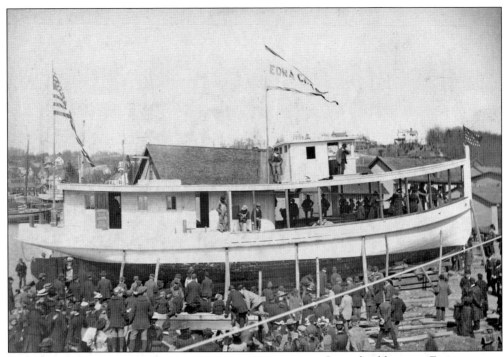

Samuel's eldest son, Erastus, began his 60-year shipbuilding career helping in his father's yard. He served as a marine architect, designing ships and laying keels. On April 6, 1901, Northport celebrated the launching of the oyster boat *Edna Chase*, which was built by 77-year-old Erastus Hartt. It was a 100-ton steamer captained by Elmore Ketcham.

Oliver L. Hartt (1848–1921), the son of Erastus Hartt and Hannah A. Brown, continued the family business into the next century, making the transition from wooden sail-powered vessels to steamers. Collectively, the three generations of Hartt shipbuilders produced scores of vessels that included sloops, schooners, brigs, and steamers.

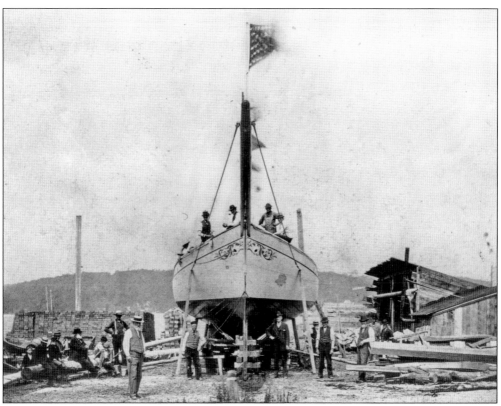

This image captures the sloop yacht *Hallie* on the ways. The boat was designed and built by Oliver Hartt. From left to right are (standing in foreground) Francis B. Olmstead, Oliver Hartt, Milton Smith, Erastus Hartt, John Ketcham, and Nathaniel Ackerly; (on the ship) Bradford Nichols, Levine Sammis, and Mose Sammis.

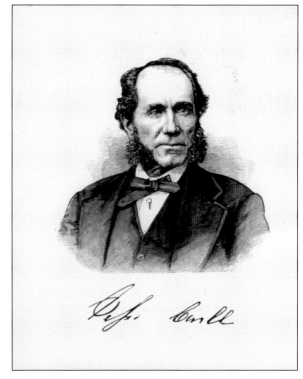

One of Northport's most prominent and influential men was the son of a farmer with only an elementary school education. Jesse Carll (1832–1902) became a master shipbuilder, owned the largest shipyard, and produced the most ships in Northport during his 50-year career. Having lost their father as a teenager, Jesse and his brother David took an apprenticeship in the shipyards of Port Jefferson.

Jesse and David returned to Northport in 1854, and with a $400 inheritance, they went into business together under the name D.&J. Carll Ship Builders. Initially Jesse and David were only able to afford half an acre along Bayview Avenue. Their reputation for fine craftsmanship and quick construction spread rapidly, however, after they completed their third contract, a double-decked bark named *Storm Bird*, which only took 87 days to build.

Shipbuilder Jesse Carll's house, originally built around 1860, was at 52 Bayview Avenue, across the street from his yard. With 15 rooms and a billiard table on the top floor, Jesse and his wife, Ann E. Carll, entertained the likes of the Vanderbilts, the Rockefellers, and the Astors while they waited for work to be done on their yachts. The house underwent a major remodeling in 1876 by Benjamin T. Robbins.

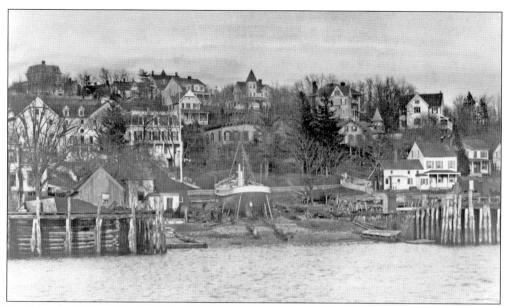

By 1865, the Carll shipyard had grown to contain 22 acres directly across the street from Jesse's house. That year, a disagreement led David to part ways with his brother and open his own yard in City Island. Jesse went on to reign as Northport's leading shipbuilder, having two marine railways and employing up to 100 men at a time.

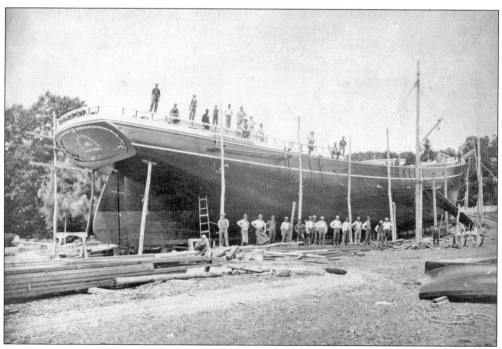

Jesse himself designed many of the ships he built. Sometimes he would become part owner, taking a share of the profits of a vessel as partial payment. He even built a ship entirely for his own account in 1883, named *Allie R. Chester*, which is pictured here. It was 144 feet long and made of yellow pine, oak, and chestnut. It was lost in a gale in 1889 carrying a cargo of phosphate.

From the late 1870s until his death in 1902, Jesse Carll suffered from stress and anxiety, having two near-breakdowns that necessitated respites to Mexico. He came to rely on his son Jesse A. Carll, who became the manager of the yard in the 1890s. As the shipbuilding industry began to decline around the turn of the century, Jesse Jr. kept the business going with repair work, but he eventually sold it in 1915. The shipyard was turned over to the village for use as a park in the 1920s.

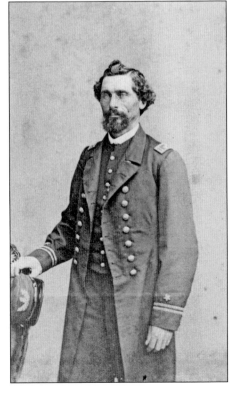

At the age of 14, Jonas Higbee went to work on his father's ship, later becoming captain of a packet sailing between Northport and New York City. Jonas gained an excellent reputation, and Jesse Carll asked him to command his schooner, *Storm Cloud*. Jonas enlisted in the Navy during the Civil War at the age of 40 and was assigned to the USS *Powhatan*, which was instrumental in blockading Southern ports. After the war, he became a commander of the Grand Army of the Republic post.

During a northeast storm on Sunday, November 1, 1846, Capt. Selah Bunce (right) and Capt. John Udell (below) were going home from church when word came that a steamer was in dire trouble off Crab Meadow and was being pushed toward the reef at Eaton's Neck. Captain Udell immediately organized a crew and secured a whaleboat. With Captain Bunce at the helm, they were the first boat to come to the rescue. All of the 150 people aboard *Rhode Island* were saved. The grateful passengers from Boston later presented a gold medal to Captain Bunce for his "intrepidity and courage." Bunce maintained that it was Captain Udell who was really the organizer of the rescue and in his will directed that the medal be given to Udell's daughter, Alice (who later became Mrs. Charles T. Sammis). John Udell was only 29 at the time of the rescue and died of cholera the following year.

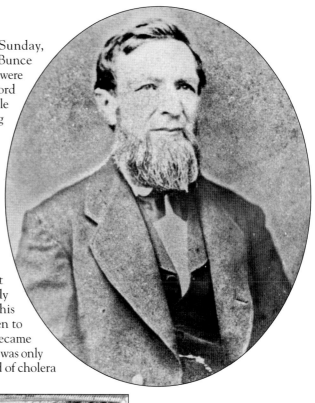

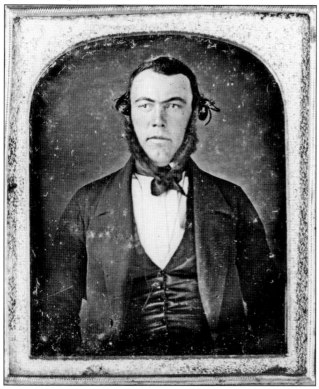

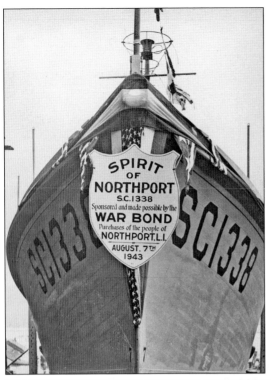

On August 7, 1943, the subchaser *Spirit of Northport* was launched from the Abrams shipyard in Halesite with a great ceremony. The townspeople of Northport bought $200,000 in war bonds in order to fulfill their quota and have the ship built in support of the war effort. As was the tradition, the crew members were "adopted" by Northport. The ship was assigned to the Pacific fleet and was sunk during a typhoon near Okinawa.

Capt. Dexter Cole Seymour (1890–1979), grandson of oyster baron Dexter Cole, stands aboard his tug *Charlotte* in this 1967 photograph. The owner of Seymour's Boat Yard, which he established in 1923, he was also Northport's harbormaster for 46 years. Seymour's willingness to help those in trouble, his craftsmanship, and his dedication to the community embody the true spirit of Northport. *Charlotte*, named after his daughter, was donated to the Suffolk Marine Museum in 1984.

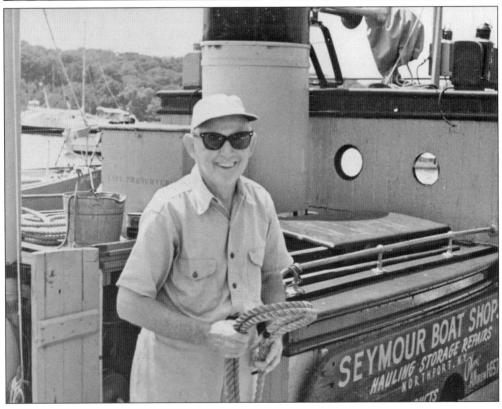

Three

INDUSTRIAL TOWN

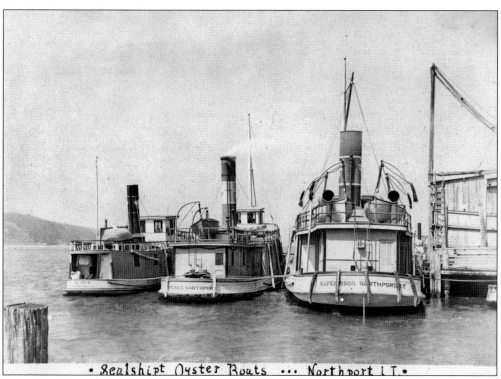

• Sealshipt Oyster Boats ... Northport L.I. •

Long Island's north shore had always been the perfect ground for the natural breeding of oysters. The practices of managing oyster beds, leasing underwater grounds, and seeding made shell fishing a leading industry in the mid-19th century, pumping money and jobs into Northport's local economy. Three area men who saw the potential of this growing business—Dexter Cole, Andrew Ackerly, and Stanley Lowndes—became so successful that they were known around Long Island as the "Oyster Barons of Northport."

Around 1850, Capt. John Lowndes became the first man to seed oysters in Northport harbor. His son Stanley (in the driver's seat at left) followed in his father's footsteps, growing and harvesting his own oysters. Stanley started his company, S.H. Lowndes & Co. Oysters, around 1892.

In 1895, Stanley Lowndes built a beautiful home at 155 Bayview Avenue. The oysters were processed on the docks in front of his home, shown below, before they were delivered to hotels in New York City or shipped in bulk to production sites in Connecticut. The business was sold to Sealshipt Oyster System in 1908 for about $7.5 million. Lowndes died six years later at the age of 57.

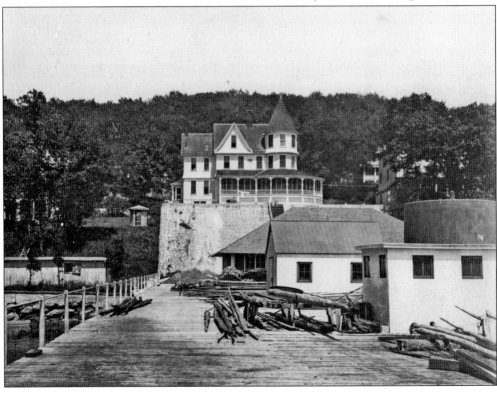

One of the founders of the local oyster business, Andrew Ackerly, pictured at right with his son Frank, "started out with tongs and a row boat, determined to succeed," according to the *Long-Islander* newspaper. His brother, Nathaniel, became a lawyer and was elected to state office. Nathaniel used his position to help Andrew's growing business by framing and passing laws granting land for the development of oyster interests in Northport.

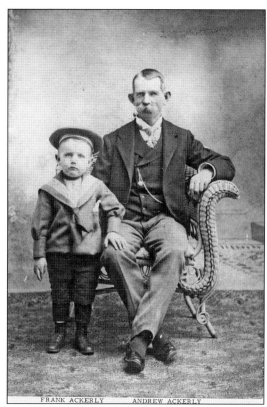

FRANK ACKERLY ANDREW ACKERLY

Through the years, Andrew employed numerous vessels and workers and became one of Long Island's largest growers, taking up as much as 1,000 bushels of oysters a day. His docks, shown here around 1925, were located along the waterfront on Bayview Avenue and Lewis Road. The oyster industry declined rapidly in the 1930s due in part to the proliferation of starfish, inbreeding, and other environmental causes.

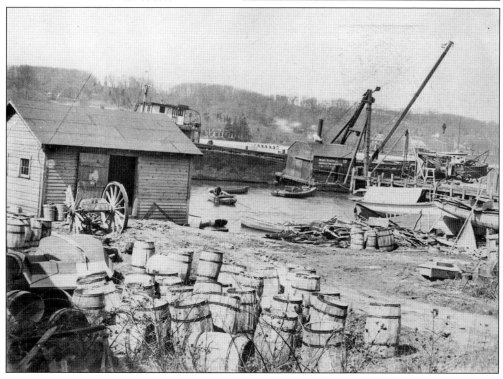

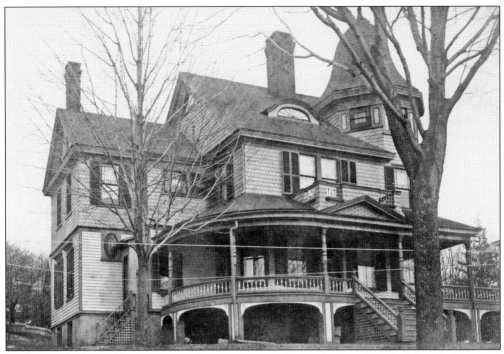

Andrew Ackerly lived at 67 Bayview Avenue in a grand house built in 1889 by John W. Olmstead for sand dealer Elbert Arthur. Arthur sold the house to Andrew without ever living in it, stating that the village had become too cosmopolitan for his taste. Nathaniel, Andrew's bother, lived in the house next door.

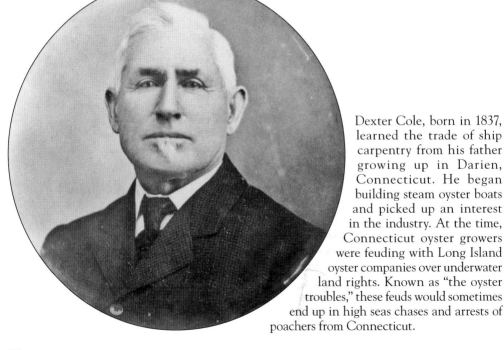

Dexter Cole, born in 1837, learned the trade of ship carpentry from his father growing up in Darien, Connecticut. He began building steam oyster boats and picked up an interest in the industry. At the time, Connecticut oyster growers were feuding with Long Island oyster companies over underwater land rights. Known as "the oyster troubles," these feuds would sometimes end up in high seas chases and arrests of poachers from Connecticut.

In 1889, Dexter moved to Northport to harvest oysters off the coast of Long Island legitimately. He partnered with Edward Thompson, a pioneer in oyster harvesting and president of the law book publisher Edward Thompson Company, to found the Northport Oyster Company. Dexter designed and owned the oyster steamer *Mystery*, which was built in 1902 by Jesse Carll. The crew pictured here includes Clifford Blydenburgh (standing, left), Dexter Seymour (Cole's grandson, standing with pole), and Jesse Tuthill (standing, right).

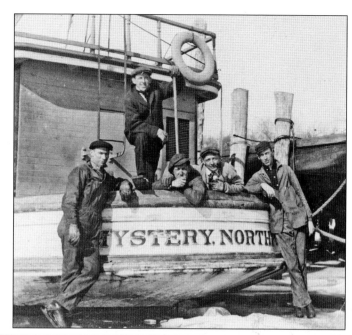

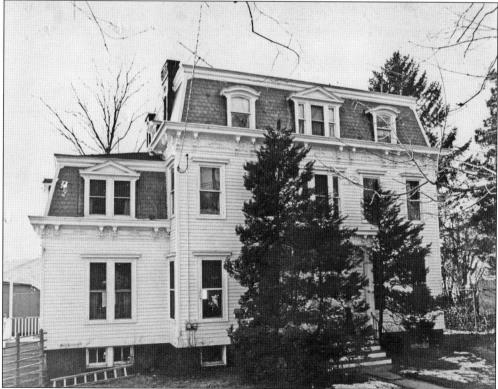

Dexter Cole purchased the house at 63 Bayview Avenue, which had been built in 1885, from Edward Thompson in 1891. It stands today as Seymour's Boat Yard. Cole died in 1917 at 81. A custom-built dollhouse of the Cole-Seymour house was exquisitely decorated by Dolly Hooper and is cared for by the Northport Historical Society.

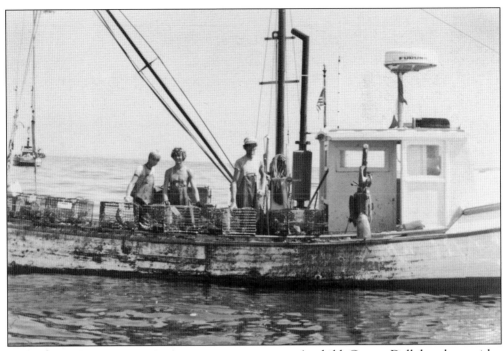

As child, George Doll dug clams with his feet along Northport's shoreline to earn extra money. His love of the water grew, and after serving in the Army's Old Guard during the Vietnam War, Doll began his lifelong career as a lobster fisherman. Doll is an example of the many baymen who have earned their living harvesting the natural resources of the Long Island Sound. (Courtesy of George Doll.)

George Doll remembered watching a bulldozer raze the old Scudder homestead as a young man. That image stuck with him, and one of his accomplishments as mayor of Northport was to reform the historical preservation section of the village code. During his three terms as mayor, which began in 2006, Doll also received grants to revitalize the wastewater treatment system and allowed for outdoor dining along Main Street. (Courtesy of George Doll.)

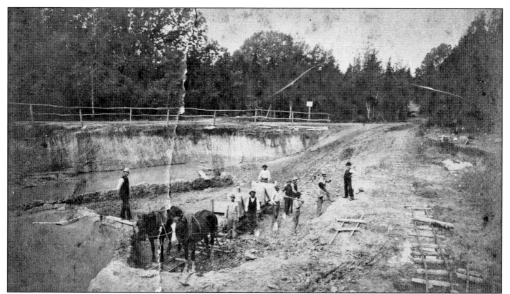

Elbert Arthur began his sand mining operations in 1860, first leasing lands and then mining his own land where the current National Grid power plant is located. Explosives were used to bring down portions of the cliffs. Then, as this c. 1875 photograph shows, workers filled horse-drawn handcars with sand and gravel, which would then travel along tracks from the sound-side bluffs to a dock on the bay side where schooners awaited shipment. (Courtesy of Edward Carr.)

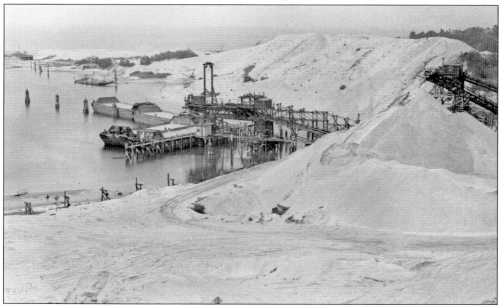

Elbert Arthur died in 1906 and his children sold the estate. In 1927, Metropolitan Sand & Gravel bought the operation. In this 1952 photograph, it is clear that shovels and horse-drawn carts gave way to large conveyor systems and barges. Plans for expansion were stopped when the Skidmore heirs would not give up their right-of-way to the family cemetery plot, located near the intersection of Eaton's Neck Road and Ocean Avenue. In 1964, Long Island Lighting Company (LILCO) began construction of a new power plant, and Metropolitan Sand & Gravel ceased operations. (Courtesy of Edward Carr.)

P. O. Northport, N. Y., *April 7* 1891

Capt. C. G. Payne or owners of Schoner May Elizabeth

Bought of N. W. GODFREY,

— DEALER IN —

SCREENED WHITE GRAVEL, GRIT AND SAND,

POST-OFFICE ADDRESS, NORTHPORT, N. Y. TELEGRAPH ADDRESS, PORT EATON, N. Y.

Works at Port Eaton, L. I.

1890			
Nov	To Manilla	2	25
	Scoop		85
	1 Dish Pan	1	30
	1 Wash Dish		15
	Rec Payment	$3	55
	N. W. Godfrey by J—		

The tip of West Beach, now known as Sand City, was also the site of a large sand mining operation. In 1884, Nicholas Godfrey convinced the owners of the land, Oliver and Mary Jones, to go into business with him. He brought in his innovative digging machine, which he invented, and built a large home, stores, a telegraph office, and workmen's cottages. Many of the laborers were Italian immigrants who worked the dredges. The area officially became known as Port Eaton.

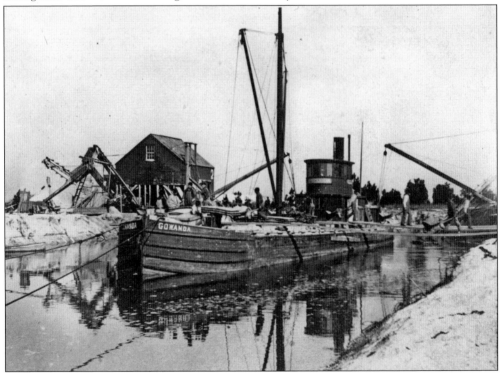

Two canals were dug. The west canal was cut on the southern tip of the beach, and the east canal's entrance was near Price's Bend. The sand barge *Gowanda*, shown here on one of the canals, was owned by Godfrey's second-in-command, Ben Blydenburgh, who ran the operation when Godfrey was absent.

After Nicholas Godfrey's death in 1899, Port Eaton changed hands and eventually was abandoned. In 1911, Henry Steers made his own offer to the Jones family, revived operations, and named the area Sand City. This aerial view of Sand City, taken in the 1950s, shows how much sand had been removed. The three strips of land were once all one piece. Today, the strip in the middle is just a small island containing the concrete ruins of the once flourishing sand mining industry.

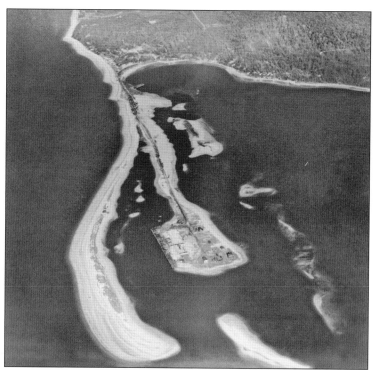

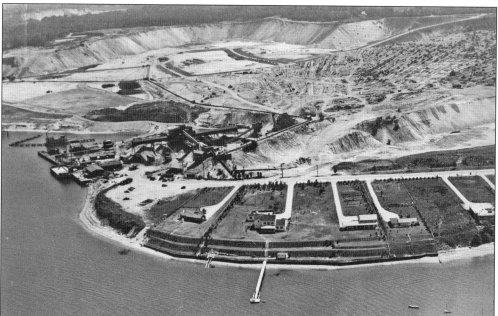

In 1923, the Steers Company moved to the eastern end of Northport Bay and began mining Bluff Point. Residents looked for a way to stop the sand mining, which was drastically altering the coastline. In 1952, J. Rich Steers Jr., president of the corporation, agreed to a reclamation project. A park, a beach, a marina, and approximately 200 homes were built; some of the homes are under construction in this photograph. In September 1968, all sand mining operations ceased. The area is now lovingly referred to as "the Pit."

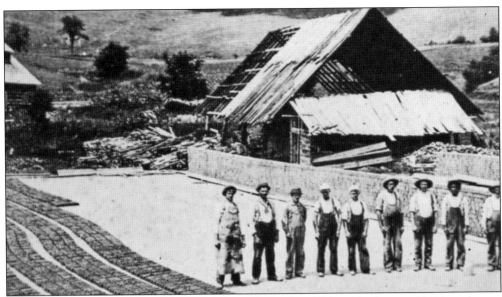

As early as 1865, bricks were manufactured on the beach at Makamah. A second brickworks was later established farther east at Fresh Pond. The brickyards produced millions of bricks annually for shipment to New York. In 1903, a state-of-the-art brickworks capable of producing half a million bricks a day was proposed for the Fresh Pond site on land leased from Henry C. Brown of Breeze Hill Farm (see page 38). The venture was short-lived. But Brown established his own, smaller venture, Brown Clay Works. His bricks were marked "B.B.B." The initials are either in honor of the company's three owners, Henry Brown, his wife, Juliet, and his son, J. Cornell, or they stand for "Brown's Better (or Best) Bricks."

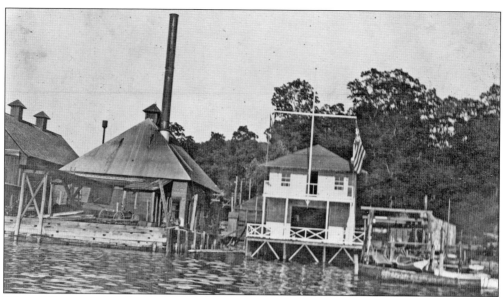

Edward Thompson led the push to introduce electric power to Northport. He and other business leaders formed the Northport Electric Light Company in 1893. Eighteen months later, in January 1895, the plant (above, left), situated on the harbor across from the Edward Thompson Company's offices, was providing the electricity to light 500 homes and businesses in Northport. The small plant was the first in the town of Huntington and one of the first on Long Island. It included a pair of boilers and a pair of engines. One boiler and engine operated for two weeks, and then the other was put into service.

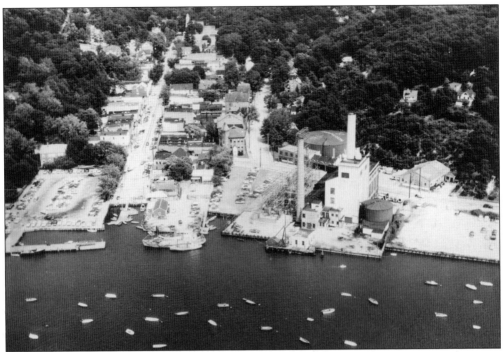

In 1911, the Northport electric company combined with companies in Amityville, Sayville, and Islip to form the Long Island Lighting Company (LILCO). The plant at Northport was expanded and became the chief generating plant until demand outpaced capacity in the mid-1950s. The plant was mothballed in 1954 but remained available to meet peak demand as needed until it was dynamited in 1968. The land, which had been leased from the Town of Huntington, was transformed into Cow Harbor Park. LILCO built a much larger plant in Crab Meadow that started providing electricity on a small scale in 1962. That plant has since been expanded and continues to operate.

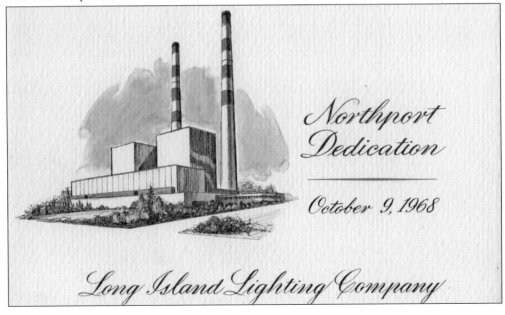

Northport Dedication

October 9, 1968

Long Island Lighting Company

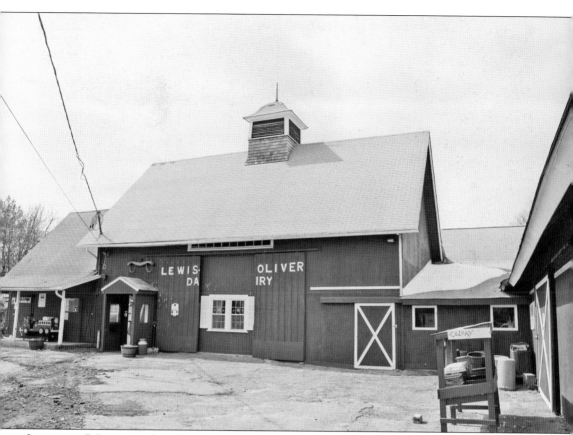

Livingston P. Lewis purchased the only dairy farm within the bounds of the incorporated village of Northport in 1920. Although Lewis grew crops and raised horses here, the main focus was milk production for distribution throughout the area. At its peak, the farm had 63 cows. In 1953, Lewis sold the farm to Kenneth Gloyd, who merged it with the Oliver Dairy of East Northport. Even after the cows were gone from the farm, milk was distributed from here under the name Lewis Oliver Dairy. The 1898 barn and surrounding pastures were purchased in 2007 by the Town of Huntington and Suffolk County to be managed by the nonprofit organization Friends of the Farm.

In 1883, Henry Cartwright Brown, who was associated with the Long Island Brewery in Brooklyn, purchased 400 acres overlooking the Long Island Sound in Fort Salonga. Brown, who had been a rancher in Colorado when he was first married in 1874, established Breeze Hill Stock Farm, where he bred and raised horses, cattle, sheep, and Angora goats. By the early 20th century, he had 500 sheep and 200 head of cattle in addition to horses and goats. The goats were used to clear undergrowth on the property. In 1906, Brown expanded into brick manufacturing (see page 34). The land is now Indian Hills Country Club.

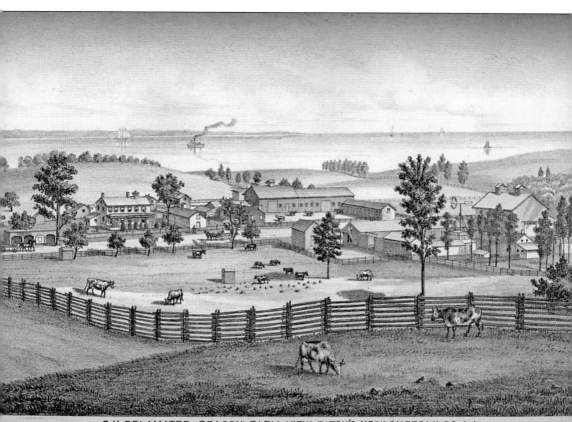

C.H.DELAMATER, BEACON FARM VIEW, EATON'S NECK, SUFFOLK CO., L.I.

During the Civil War, Cornelius H. DeLamater assembled a 1,250-acre farm that covered almost two-thirds of Eaton's Neck. Due to its location near the lighthouse, he named it Beacon Farm. DeLamater owned an iron foundry in Manhattan where the turret, engines, and weapons of the ironclad *Monitor* were built. His farm was an important breeding ground from which livestock such as pedigree cattle, Beacon Downs sheep, and other stock spread through Long Island. The farm's manager ,William Crozier, also raised imported Berkshire pigs, white and bronze turkeys, Peking ducks, Plymouth Rock and other chickens, and more. The farm was eventually inherited by his daughter, who sold it in 1920. In 1936, a large part of the farm was sold to Henry S. Morgan, whose descendants continue to own it.

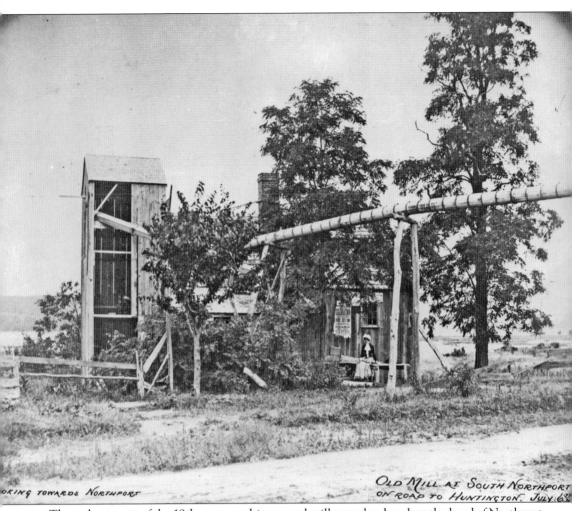

OKING TOWARDS NORTHPORT

OLD MILL AT SOUTH NORTHPORT
ON ROAD TO HUNTINGTON. JULY 6th

Throughout most of the 19th century, this unusual mill was a landmark at the head of Northport Harbor. At the low point on the south side of what is now Route 25A, where the water pumping station is located, a dam was built to impound water. A trough carried the water over the roadway at a height that permitted loaded wagons to pass underneath. The trough carried the water to the large overshot wheel that measured five feet wide and 25 feet in diameter. The mill had been built by Lafayette Chichester in the early 19th century. It was completely refurbished in 1879 by the last miller, Henry N. Taylor. The mill blew down in a gale in 1893, and its remains were removed three years later.

Four

RIVALRY

Northport's economy in the 1800s relied on hard labor and waterfront-related businesses such as shipbuilding, oyster farming, and sand mining. These industries made small fortunes for several Northport entrepreneurs. Towards the end of the century, Edward Thompson and Henry S. Mott would enter into businesses in Northport, each successful in his own right, but their rivalry would become most influential in shaping the village and ushering in Northport's golden age.

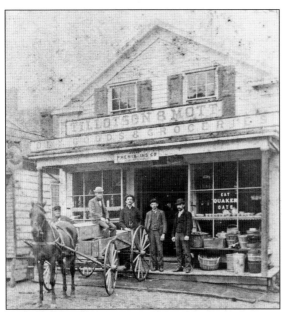

Henry Stanton Mott (1855–1928) descended from a long line of Northport sea captains, including Jesse Mott, captain of the ill-fated *Rhode Island*. However, Henry decided a life on the sea was not for him. In 1875, at 20 years old, he partnered with Civil War veteran Alfred Tillotson to open a dry goods store at 44 Main Street. From left to right are Tillotson, John Hartt, Edward Skidmore, and Henry S. Mott.

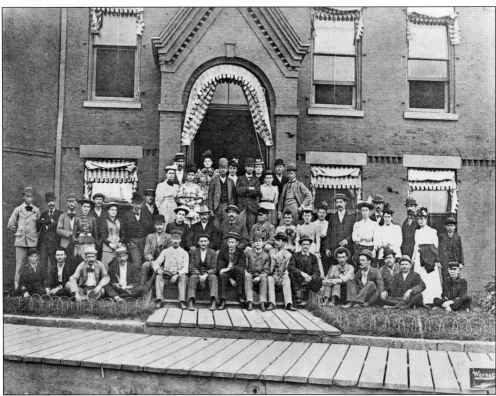

After meeting lawyer James Cockcroft, Irish immigrant Edward Thompson (1844–1923) decided to put the money he made from his oyster business into a new venture: a law book publishing company. In 1881, they founded the Edward Thompson Company. Here, with their employees, Thompson is seated at the center of the second row, with the straw hat. Secretary Edward Pidgeon is seated to the left, and James Cockcroft is seated to the right.

In 1889, Mott added an insurance and real estate business in the back of the general store. The village was booming as the success of Thompson's publishing company fueled the economy, and Mott realized that what Northport needed was a bank. In 1893, he established the Bank of Northport, which later became Northport Trust. Edward Thompson made the bank's first deposit, $5,000. Mott moved the bank into the very distinctive building at 45 Main Street in 1895.

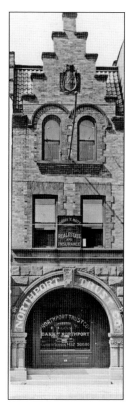

In 1887, Thompson published the country's first legal encyclopedia, *The American and English Encyclopedia of Law.* This publication proved to be so important and successful that the company was able to expand and build the brick fireproof building that still stands today on the corner of Woodbine and Scudder Avenues. Volumes of its law books were shipped to Europe, India, and Australia, which made the village of Northport known around the world.

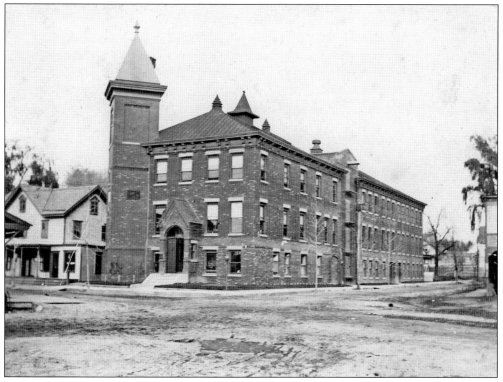

Thompson recruited young lawyers from across the country to work as editors and writers. He employed nearly 200 workers, including 25 lawyers, 12 stenographers, and 40 traveling salesmen. As a result, Northport's population was growing, and Thompson helped to meet the basic needs of the community. He formed the fire department, the waterworks, the lighting company, and a steamer service.

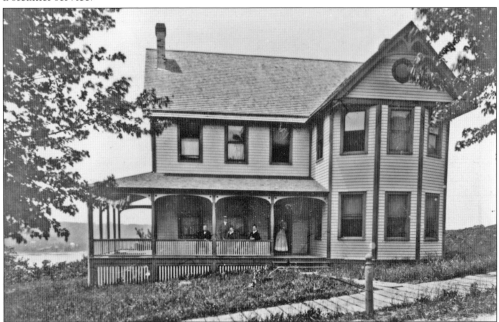

Thompson formed Northport Real Estate and Improvement Company to provide housing for the growing population. Highland Avenue was nicknamed "Lawyer Street" because so many of Thompson's lawyers lived in the new boardinghouses built there, like this one at 35 Highland Avenue. Streets were named after employees and family members, including McKinney Avenue and Rutledge Avenue.

In 1901, Henry S. Mott joined the rival Brooklyn-based American Law Book Publishing Company and served as its treasurer. Thompson insisted Mott abandon his position. If he did not, Thompson threatened to pull his company's money out of the Bank of Northport and open his own bank. Mott was undaunted, and after Thompson pulled the money, Mott reorganized his bank under the name Northport Trust Company. Many of Northport's prominent businessmen became officers and directors of Northport Trust, including Henry's son, Charles.

True to his word, in 1909, Edward Thompson opened the First National Bank of Northport with offices at 55 Main Street, doors away from Mott's bank. He convinced a number of prominent businessmen to move their accounts. Thompson also partnered with William Codling to compete with Mott's real estate interests.

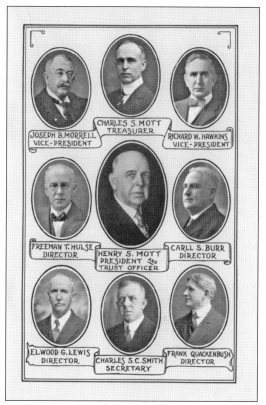

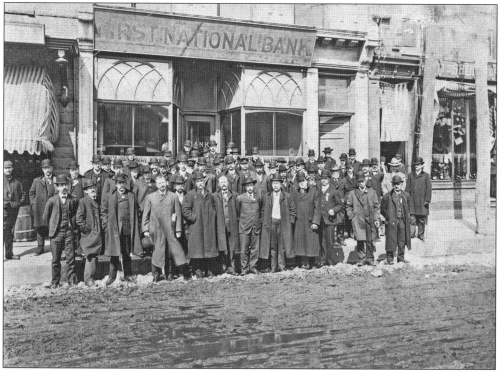

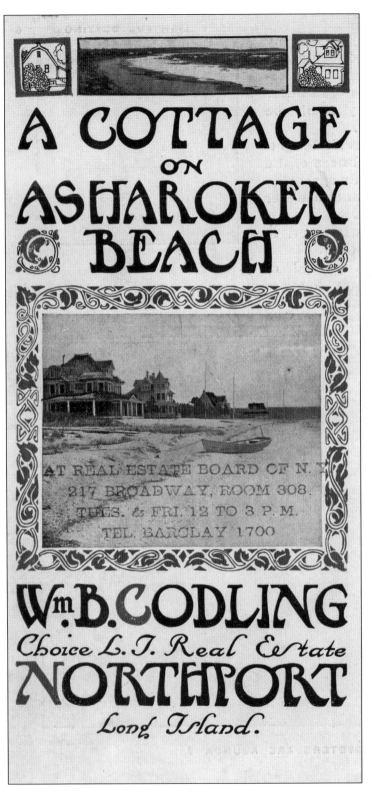

A COTTAGE ON ASHAROKEN BEACH

AT REAL ESTATE BOARD OF N. Y.
217 BROADWAY, ROOM 308.
TUES. & FRI. 12 TO 3 P. M.
TEL. BARCLAY 1700

Wm. B. CODLING
Choice L. I. Real Estate
NORTHPORT
Long Island.

William B. Codling moved to Northport in 1885 determined to become a successful lawyer in the real estate business, and it took him just five years to become one of Suffolk County's largest landowners. From his offices in the First National Bank of Northport, Codling created housing developments all over the county and in Northport, including on a narrow strip of beach property he named Asharoken Beach. He distributed pamphlets throughout New York City advertising his beachfront properties. Codling lived on a large estate in Northport called Seaview and owned a cottage on Asharoken. He was a highly respected businessman, admired for his integrity and ethics. When he died in 1924 after being struck by a car, one of the largest funerals in the village was held at St. Paul's Methodist Episcopal Church, where he had been a member of the choir for 25 years.

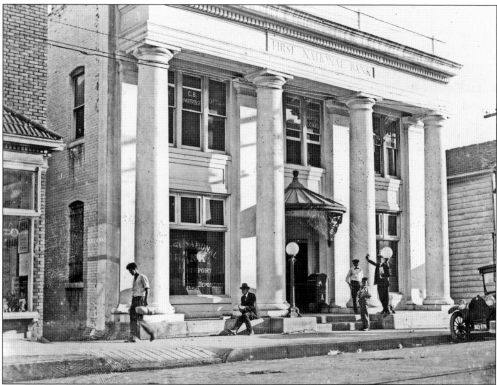

In 1912, Thompson moved his First National Bank of Northport across the street to this large classical-style building, which still operates today as a bank at 54 Main Street. The bank building replaced a row of 19th-century wooden buildings known as the Dickerson Block (see page 72). When the bank first opened until 1921, the right side of the building served as the post office.

Not to be outdone, in 1925, Henry S. Mott constructed an impressive new building with a marble facade for the Northport Trust Company at 111 Main Street. This building stood until 1957. The bank's vault door now serves as the door to the museum shop at the Northport Historical Society. Mott died on November 26, 1928, at the age of 76, having the distinction of being Northport's first banker.

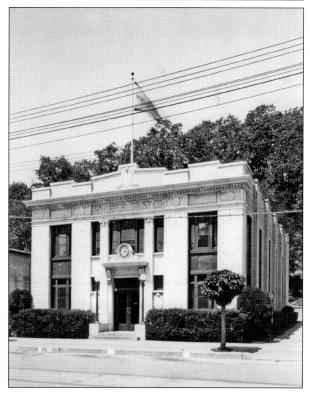

AGAINST
INCORPORATION

A Mass Meeting will be held at

UNION OPERA HOUSE,
Northport, on

MONDAY EV'G, OCT. 1, '94,
AT 8 O'CLOCK.

The meeting will be addressed by

WILLARD N. BAYLIS, Esq.,
of Huntington, and others.

EVERYBODY INVITED.

POINTERS TO ASK INCORPORATORS.

In regard to taxation in Northport the people would like to know how it is, Mr. Pidgeon's house on Bayview avenue is taxed for $350, and others right along side, not worth near as much, taxed for $700 ?

Also, want to know how it is that Mr. Fowler's farm was taxed before he bought it for $1,400, now taxed $250 ?

And the Edward Thompson Company, insured for $39,000 personal property, taxed for $500 ?

And these are the leading men in favor of incorporation.

Like many other Long Island communities, Northport began exploring the idea of incorporation in the 1890s. Thompson Company principals felt incorporation would allow residents to more fully regulate their affairs, create a better quality of life, and stimulate the local economy. Others, like Jesse Carll and small business owners, disagreed, arguing incorporation threatened to increase costs and concentrate power with just a few influential people. Citizens were fiercely divided on the issue of incorporation. Rallies for and against were held.

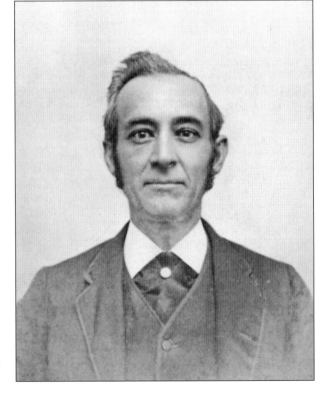

On October 2, 1894, the vote was held at the Northport House. Those in favor of incorporation won, 255 to 143. Later that month, a second election was held for a president and board of trustees. Tinsmith William H. Sammis became the first president, the equivalent of mayor, of the incorporated village of Northport. The board got right to work to improve roads, create sidewalks, and install sewers. Electric lights and telephones soon followed. Edward Thompson became the second president of the village in 1898. (Courtesy of the Northport–East Northport Public Library.)

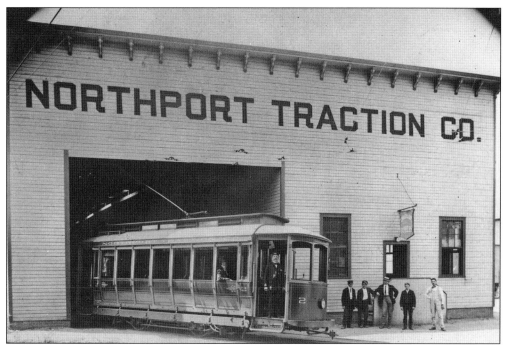

In 1901, the Northport Traction Company was formed with backing from the Long Island Rail Road and the Edward Thompson Company for the purpose of building and operating a trolley line. It was to be three miles long, running from the Northport train station down Laurel Avenue to Main Street, with a turnaround and house on Woodbine Avenue.

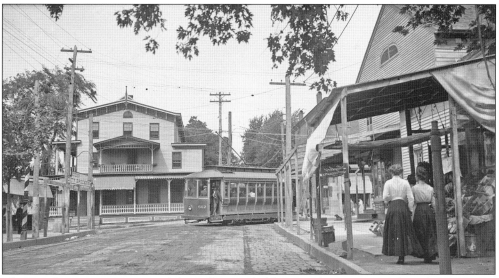

The grand opening ceremony of the trolley was held on April 17, 1902, amid much excitement. A two-man crew outfitted in uniforms and large brimmed hats made 14 stops along the route from the railroad station to the terminal on Woodbine Avenue. The trolley was a constant in Northport for 22 years. The last trolley ran on August 19, 1924, and was replaced with the buses of the Northport Transportation Company, but the tracks remain running down the middle of Main Street today.

The Edward Thompson Company grew to do over $1 million in business a year. When Edward Thompson, president, and Edward Pidgeon, secretary, retired from the business in 1897, James Cockcroft took over as president. William McKinney became vice president, and David S. Garland became secretary. The company stayed in Northport until it moved to Brooklyn and was taken over by West Publishing Company. This photograph captures moving day in 1935.

The company's move to Brooklyn in the depths of the Depression had a devastating effect on the village. Tenants came and went until 1961, when Davis Aircraft Products Co., Inc., moved in. The manufacturer was best known as the developer of the first seat belts for use in automobiles. The company employed about 100 people, including engineers, researchers, and designers. Davis moved out of the building in 1984.

Five

DOWNTOWN

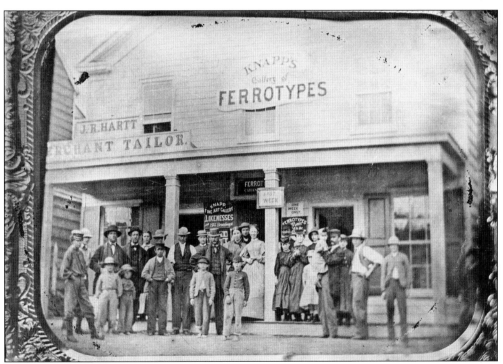

This ferrotype, taken in the 1860s, is the oldest known photographic image of Northport's Main Street. The building was home to J.R. Hartt's tailor shop and Knapp's Gallery of Ferrotypes. Unfortunately, none of these local residents has been identified. Wooden buildings like this one typified Northport's commercial district until the late 19th century, when wood gave way to brick. This building was replaced in 1895 with the stepped-gable building that still stands at 45 Main Street (see page 43). Some of the old buildings survive but are hidden behind new facades. The village stagnated in the middle of the 20th century. The lack of economic activity in the village enabled Northport's historic gems to survive until there was a greater appreciation for these wonderful buildings.

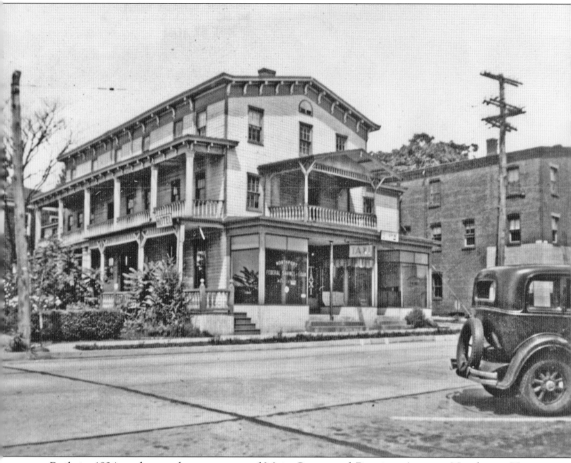

Built in 1824 at the northwest corner of Main Street and Bayview Avenue, Northport House was a village mainstay for over a century. The hotel offered first-class accommodations as well as boating, fishing, and other activities. It also became a de facto center of official business, such as auction sales of foreclosed properties and annual collection of taxes. By the 1930s, however, it had lost much of its luster. When talk of Northport having a family resort hotel was raised in 1935, the Northport House was not considered the answer. In 1937, the old hotel was purchased by Marion C. Ingersoll, who donated the building to the village to be demolished. The entrance to Bayview Avenue could then be widened, and the new village park (see page 112) could be enlarged.

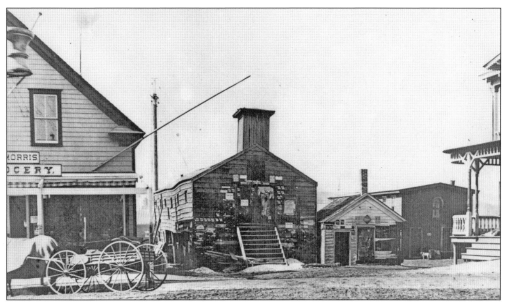

Main Street did not extend west of Bayview Avenue until 1911. Shipbuilder Jesse Jarvis built the sail loft (center) in the 1850s. A corner of the Northport House can be seen on the right. Stephen Morris moved his grocery store from 39 Main Street to the new building on the left in 1898.

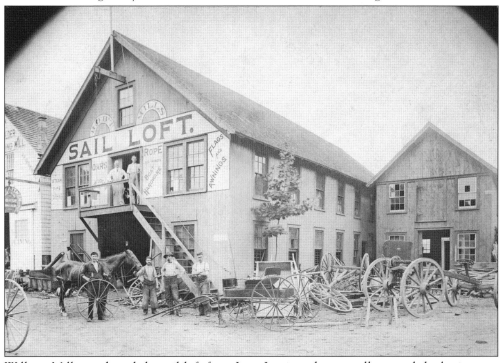

William Mills purchased the sail loft from Jesse Jarvis and eventually moved the business to the second story of the shop of John Aitken, "Practical Horse Shoer." In addition to shoeing horses, Aitken was a wheelwright, as can be seen from the pile of wagon wheels. The old Jesse Jarvis shipyard, which was on land leased from the Town of Huntington, was acquired by Henry S. Sammis.

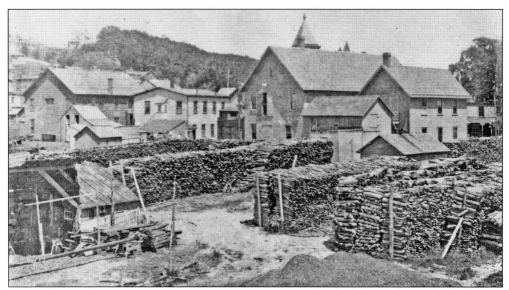

The original landing at the foot of Main Street was built to accommodate the shipment of cordwood (see page 14). In this view looking from the harbor side to the northeast, piles of cordwood attest that the trade continued throughout the 19th century. The tower of the Thomson Building can be seen above the roofline in the center. The buildings seen here faced Woodbine Avenue.

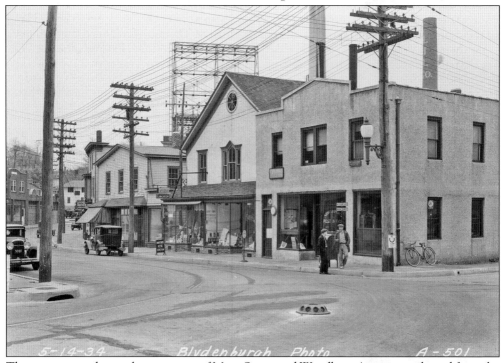

This property at the southwest corner of Main Street and Woodbine Avenue was leased from the Town of Huntington by Henry S. Sammis and his son Charles T. Sammis. The building on the corner housed the post office on the first floor. Upstairs were the offices of William A. Kissam and dentist Frank Quackenbush, who was Charles Sammis's son-in-law. The building next door was the old Presbyterian church, moved here by Henry Sammis in 1873 (see page 94).

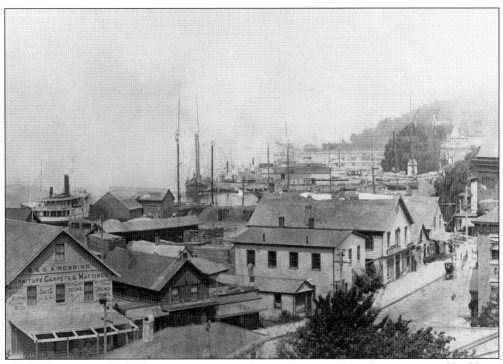

The bird's-eye view above shows an active waterfront with a row of wooden commercial buildings on the west side of Woodbine Avenue. A small part of the Thomson Building can be glimpsed along the right side of the picture. This land had been leased from Huntington until 1961, when Susan Sammis Quackenbush reached a settlement with the town to release the land. The buildings, including the 1794 Presbyterian church, were demolished, and the area was used for parking. The lot, below, was not fully paved until 1986, when the village entered into a 40-year lease of the land from the Huntington Board of Trustees.

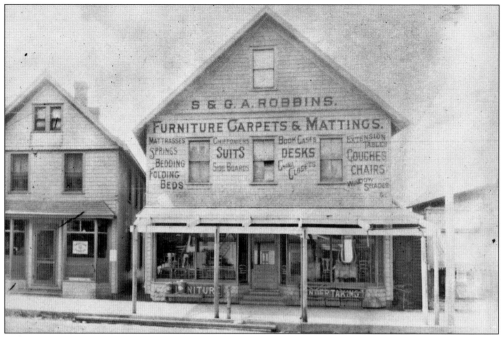

George Robbins and his nephew Samuel Robbins sold furniture from this store on Woodbine Avenue (above). In the back of the building, they also operated a funeral parlor. George drowned in May 1899 under mysterious circumstances. Samuel's son Harry took over the business until he died in 1922. In 1928, Harry's widow sold the furniture store and funeral parlor to Harry Taylor and Robert Davis. Six year later, they gave up the furniture business to concentrate on the funeral parlor, which they moved to the former home of Benjamin T. Robbins (no relation to George Robbins) on Scudder Avenue (below). The old furniture store building on Woodbine Avenue was moved to Scudder Avenue and is now the location of Snug Harbor Marine Supply.

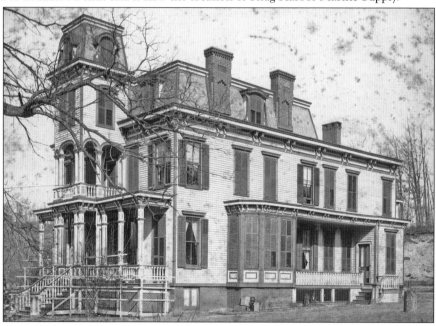

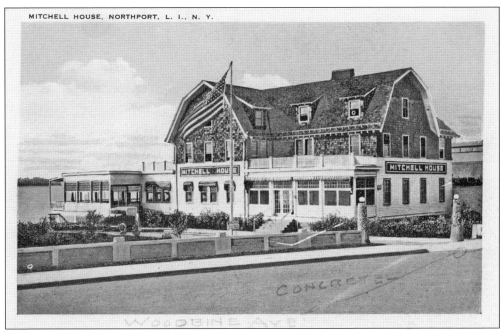

Benjamin Mitchell was the proprietor of Locust Grove and later Valley Grove on Eaton's Neck (see page 111). In 1915, after Valley Grove closed, he built a new hotel on Woodbine Avenue south of the Long Island Lighting Company power plant. Mitchell complained about the noise and pollution coming from the plant and even commenced a lawsuit against the power company. In 1925, two years after Mitchell died, LILCO purchased the property for eventual expansion of the power plant. After the power plant was demolished in 1968 and the land reverted to the Huntington Board of Trustees, the town built a marina on the property (below).

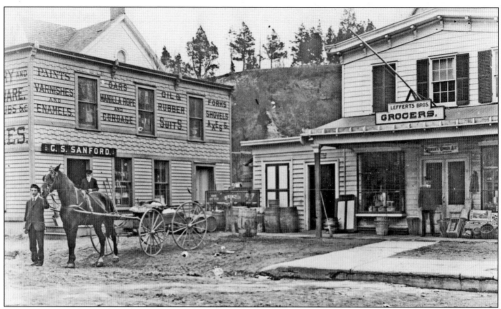

Northport native Charles S. Sanford engaged in a variety of enterprises. In the 1870s, he built carriages in a factory on Woodbine Avenue south of Main Street. After he sold the factory in 1876, he purchased a schooner and followed the water. That venture, however, did not last long. In 1878, he purchased the dry goods store of Soper & Sammis on the southeast corner of Woodbine and Scudder Avenues, pictured above. Sanford lived on the second floor. He later sold the store to Homer and Theodore Lefferts. Sanford then opened a paint store next door. The buildings were replaced when the Long Island Lighting Company had the new office building seen below constructed in 1923.

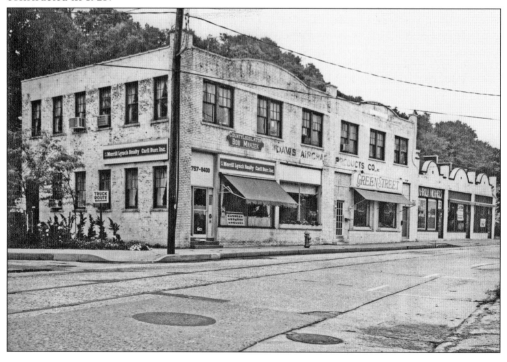

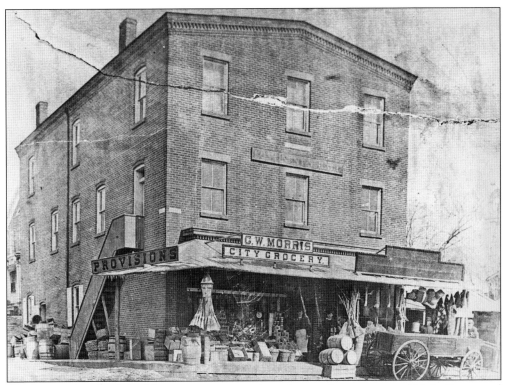

Northport's first brick building was constructed on the northeast corner of Main Street and Bayview Avenue in 1871 by Joseph and Henry Lewis, who had previously conducted a grocery business in a wood-frame building on the site since the 1850s. The grocery business was later run by George W. Morris, followed by his father, Stephen Morris, who had previously operated a grocery store on Main Street in Huntington. The building continued as a grocery store as part of the Roulstens chain. The offices upstairs were occupied by Nathaniel S. Ackerly and Rowland Miles, two prominent Northport attorneys at the turn of the 20th century. Later tenants included the Peter Pan restaurant, the Harbor Marine and Boat Shop, and the Chain Locker. The photograph below was taken before the building was renovated and restored in the late 1970s.

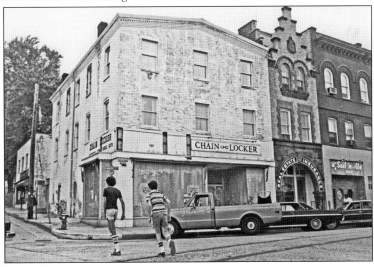

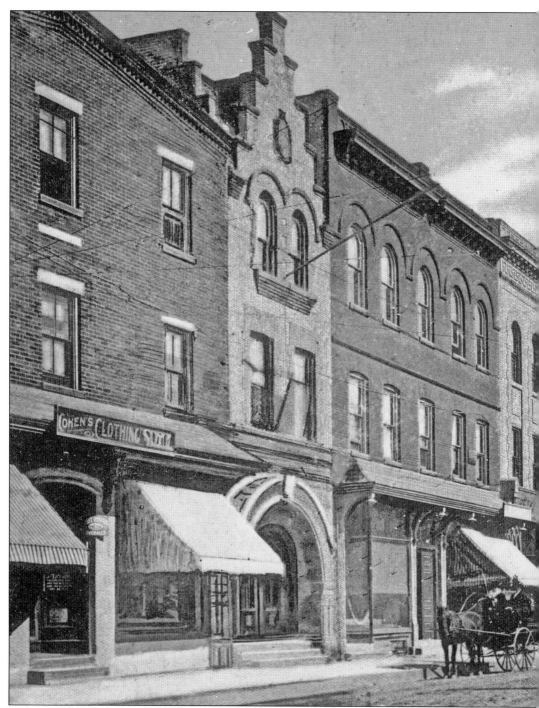

These iconic three-story buildings were constructed in the 1890s. The building with the stepped gable and the two to the east of it were built in 1895 and designed by architect Albert V. Porter. The stepped-gable building (45 Main Street) was constructed to house Henry S. Mott's Bank of Northport (see page 43). The next building (47–51 Main Street) was constructed for Henry S. Mott and his partner, Milton Smith. In the early 20th century, it was home to a nickelodeon. The

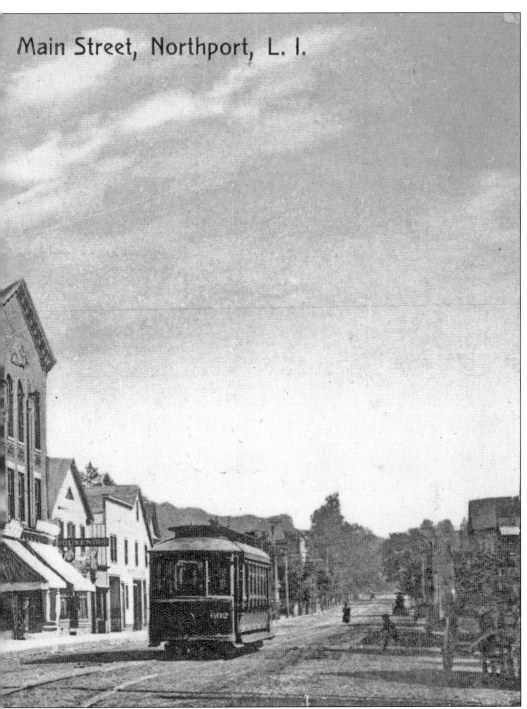

Main Street, Northport, L. I.

next building (55 Main Street) was constructed for William H. Sammis and housed Northport's second bank, the First National Bank. It has been home to the Northport Sweet Shop since 1929. The last building in the row (61 Main Street) was constructed in 1891 for Benjamin T. Robbins. The Northport Lodge of the Independent Order of Odd Fellows, established in 1847, met here.

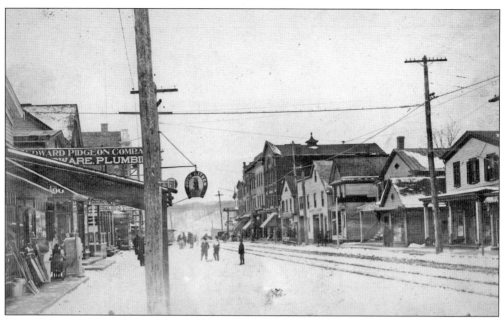

Four of the wood buildings in the middle of the block on the right side of this photograph were destroyed by fire on May 18, 1930. The fire started in a bowling alley above a garage and quickly spread. The night watchman, Thomas O'Mara, sounded the alarm and carried two children from one of the upstairs apartments. Neighboring fire departments assisted in fighting the fire, even using water from the harbor. The buildings at either end were replaced soon after the fire. The site where the garage had been remained vacant until 1977, when the current restaurant building was constructed.

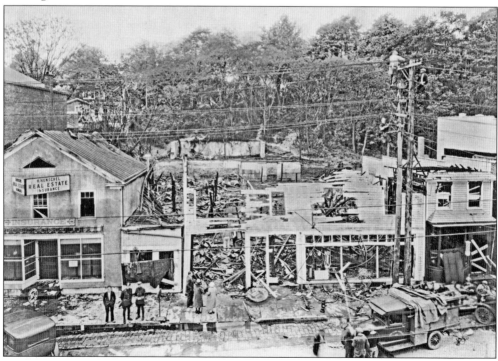

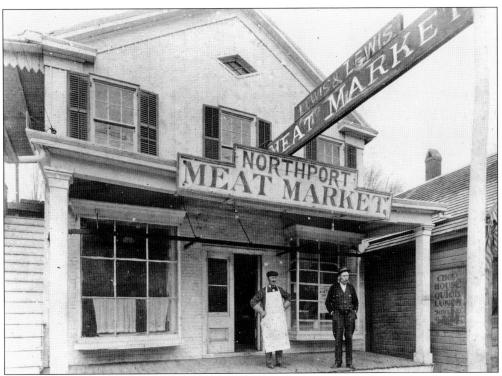

Constructed in 1871 for Henry S. Lewis, this building was purchased by cousins Charles and Elwood Lewis in 1895. The cousins operated the Northport Meat Market here. Charles retired in 1913. Elwood continued in this building until he decided to replace it with the brick building below in 1929. He continued to operate the meat market on one side and rented the other storefront. Elwood was an active member of the Northport community, serving on the Northport Board of Education and on the boards of several local cemeteries.

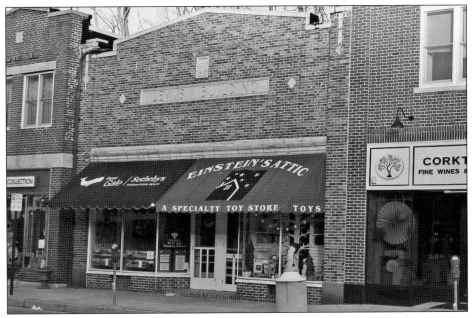

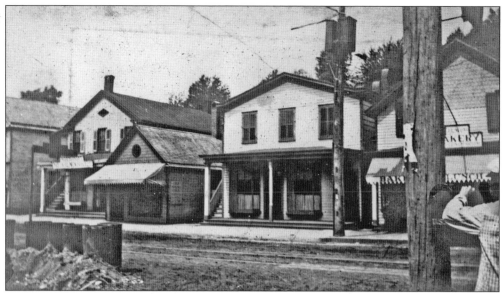

Northport's telephone offices were in the second floor of the two-story building in the center of this photograph. In 1925, George W. Brush erected a new brick building around the wooden structure to avoid disrupting telephone service in the area. When three quarters of the new building were completed, the telephone equipment was moved to the new building, the remaining section of the old building was demolished, and the last section of the brick building was finished. In 1944, Charles Wenderoth purchased the building and moved the Northport 5 & 10¢ store here. After 53 years in business, the 5 & 10¢ store, which had become a beloved landmark on Main Street, closed in 1990. Controversy greeted the announcement that national retailer the Gap would open a store in its place. There was also some disappointment when the Gap closed two decades later.

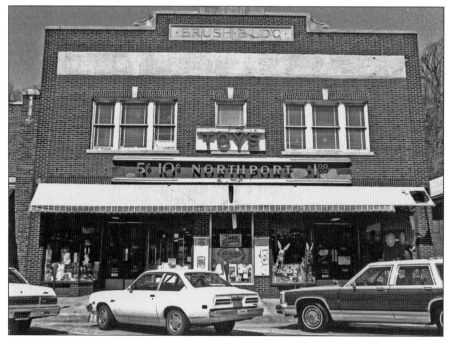

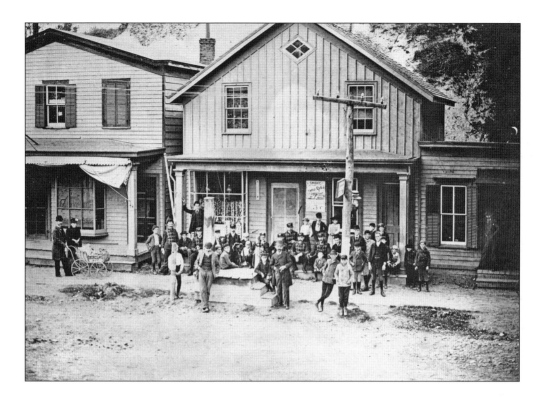

Capt. Alvin B. Lewis ran a bakery in the building on the right. The small one-story wing to the east housed the watch shop of Billy Lincoln. The platform in front was used to help passengers get onto the stagecoach or carriages. In 1937, the wooden building was replaced by the one-story brick structure below, which was home to one of Long Island's earliest grocery store chains. It is believed that the 1930s building incorporates some of its 19th-century predecessor.

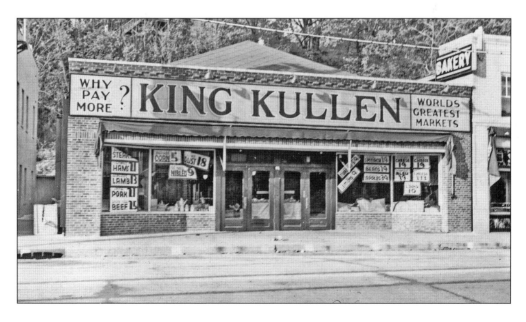

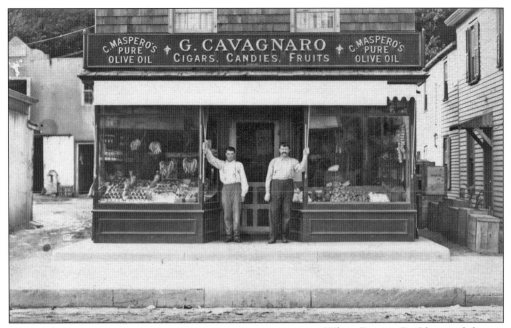

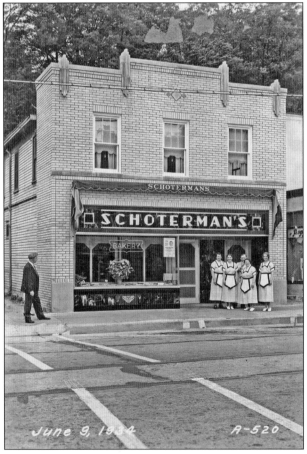

June 9, 1934 A-520

When Francis B. Olmstead dug the cellar for this house in 1873, he uncovered a sea chest full of gold coins. The origins of the treasure remain a mystery. At the beginning of the 20th century, Giuseppe Cavagnaro opened a fruit and vegetable store here. Cavagnaro would go on to own several buildings and businesses in the village (see page 124). From 1925 to 1934, the building was home to Schoterman's Bakery—the bake ovens remain today. The art deco facade was added in the 1930s.

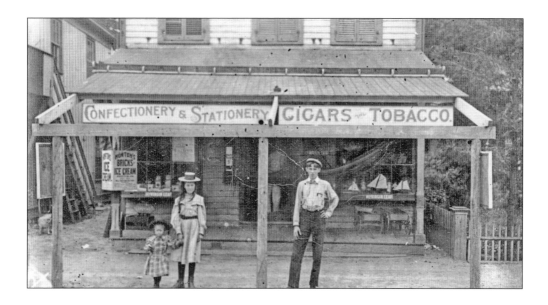

George A. Ketcham built his confectionery and tobacco store in 1878. Ketcham was known for the mineral water he bottled here. He also made his own ice cream. An icehouse in the back of the property was stocked with ice cut from Blanchard Lake in Crab Meadow. Pictured are Ketcham's three children—from left to right, William, Lillian and Bertram. Three-year-old William died in 1898 when he was playing in the store and another child accidently knocked over a bottle of carbolic acid, which was used to make mineral water. He was overcome with the fumes and died the next day. The modern exterior seen today was added in the 1950s.

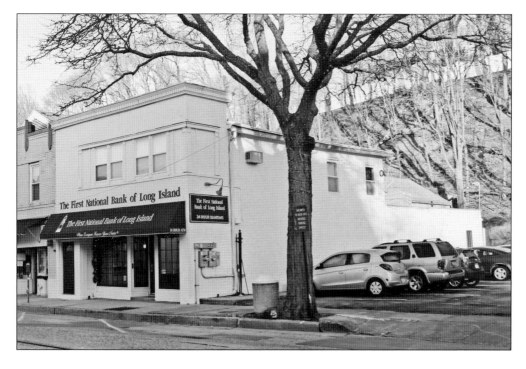

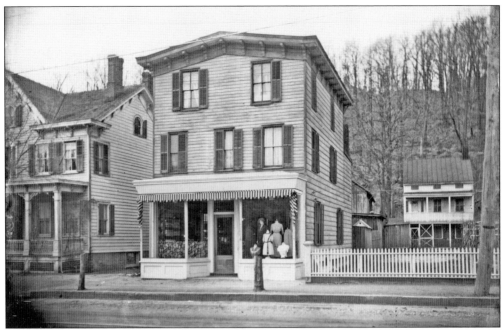

The house to the left in the picture above had been the Phoebe Arthur Boarding House, which counted lawyers employed at Thompson's publishing company among its residents. The house on the right was built around 1860. In 1910, it became the tailor shop of Polish immigrant Abraham Ingerman. Meanwhile, the boardinghouse had been purchased by rival tailor Israel C. Cohen, who converted it into a clothing store. Before long, Ingerman purchased the building from Cohen and moved it about 20 feet to the west. In the newly created vacant space between the two buildings, he built a new store, below. Ingerman converted the old boardinghouse into two stores. Later he added a brick facade and expanded his store into the old boardinghouse. He also added a brick facade to his original shop (139 Main Street) and later removed the third floor. Ingerman's Department Store remained in business until 1994.

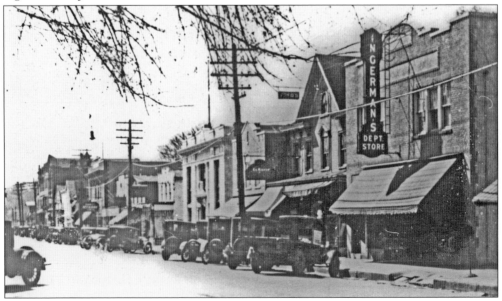

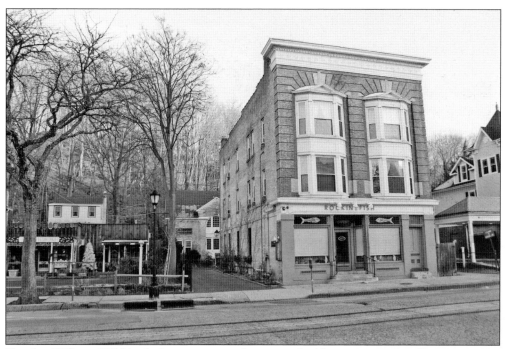

Plumber William Wild built this impressive three-story building in 1903. Equally impressive is the large brick storage barn, which is now an art gallery, he built in behind it. Wild remained in business at this location until the 1930s.

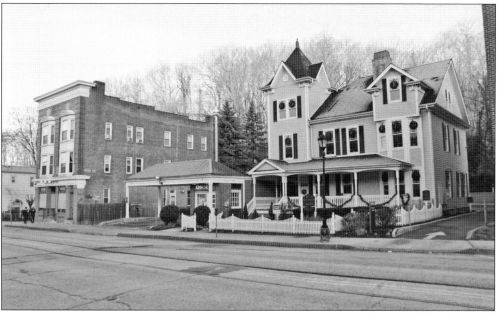

William H. Sammis was a tinsmith whose store was at 100 Main Street, now the site of Jones Drug Store (see page 78). This Queen Anne–style house was built for Sammis in 1888. When the village was incorporated in 1894, Sammis was elected the first president, or mayor. For many years, the house was the location of the law offices of Ingerman & Smith. The bank drive-through was added in the early 1970s.

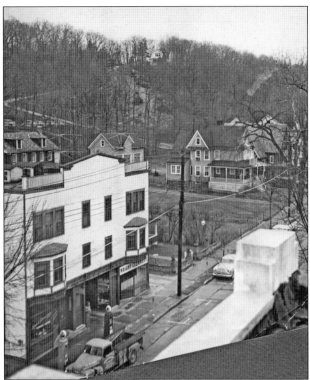

From 1876 to 1910, a Baptist chapel stood here. The small congregation did not last long, and the chapel was put to other uses, including use as a school after the Crab Meadow School burned down. The chapel was replaced in 1910 with this building, which includes a pass-through for carriages to reach the carriage houses in the back. The brick veneer was added in 1974.

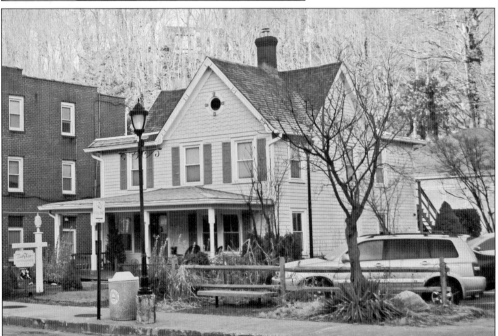

This 1880s house marks a transition from the more densely developed commercial section of Main Street to the west to the more residential character to the east. It was home to the Zanfino family for three decades. In the 1970s, the Sammis real estate firm restored the house and converted it to commercial use.

Capt. Eliphalet Skidmore was engaged in the rum and sugar trade to Barbados. When he had this house built in the mid-19th century, he placed it back from the street to avoid the spring-laden floor of the valley. By the 1980s, the house had fallen into disrepair, and the village was eyeing the property for a parking lot. Contractor Thomas Mara purchased the property instead. He renovated the house in 1984 and a year later sold the front yard to the village for parking. The garden along the walkway to the house is maintained by volunteers.

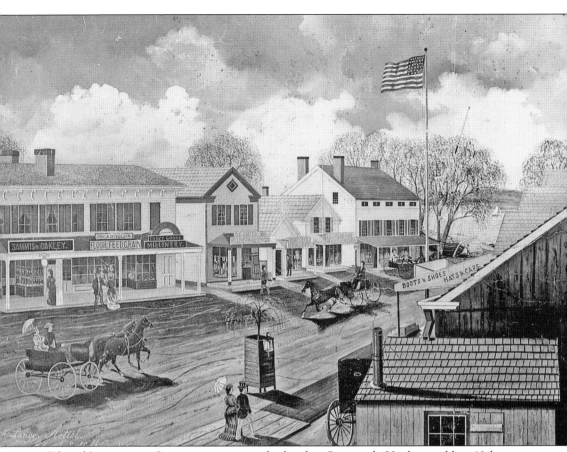

Edward Lange was a German immigrant who lived in Commack. He depicted late-19th-century Long Island farms, houses, and villages, such as in this 1880 painting of the south side of Northport's Main Street at the intersection with Woodbine Avenue. In the decades after Lange painted this view, Northport's downtown business area saw many changes. All of these buildings were replaced with brick buildings over the course of the next 50 years. (Courtesy of Preservation Long Island.)

Following early use as a law office and saloon, this building on the southeast corner of Main Street and Woodbine Avenue served as a drugstore under various owners for 80 years. Northport's first telephone was here. The building was demolished in 1930, and three new buildings replaced it and an alley to the east. The corner building has been used as a restaurant since its construction. Skipper's Pub, which opened in the 1950s, expanded into the second building in 1986. The first tenant in the third building was a supermarket.

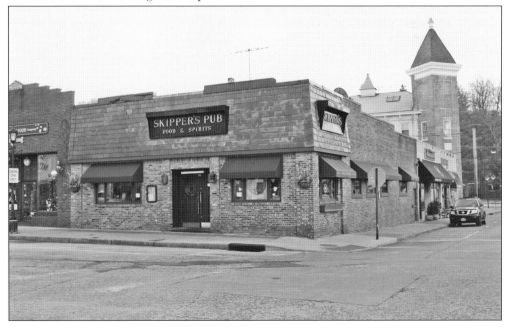

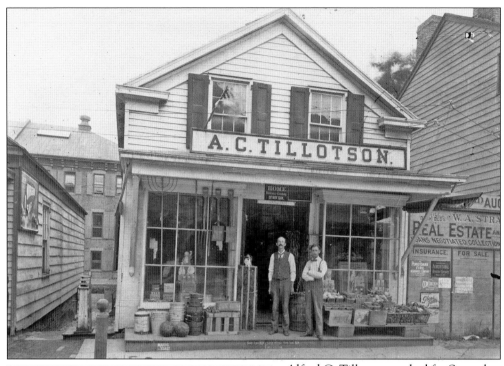

Alfred C. Tillotson worked for Samuel Spafford Brown in his dry goods store after serving in the New York Volunteer Infantry during the Civil War. In 1878, Tillotson formed a partnership with Henry S. Mott to purchase the store from Brown. Tillotson bought out Mott in 1891 and ran the store under his name until he retired around 1917. The building was replaced by the current structure in 1934. After serving as a pharmacy and health center for the Red Cross, it has been used as a restaurant or bar for the past 80 years.

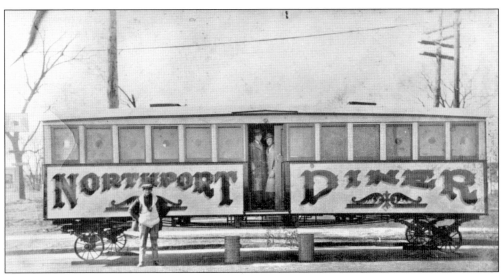

This 1909 railcar was delivered to the Northport train station in 1924 and then transported to Main Street along the trolley tracks to its current location. It continues to sit on its original wheels. Originally called the Northport Diner, it was purchased by Otto Hess in 1973 and renamed Otto's Shipwreck Diner. Otto's son Tim worked in the diner as a dishwasher and eventually began working the grill. Tim studied culinary arts at the New York Institute of Technology and took over the diner when his father retired in 1996. The name was appropriately changed to Tim's Shipwreck Diner.

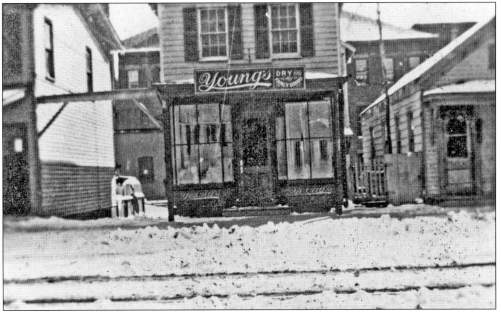

In the Lange painting on page 72, this store is occupied by P.E. Smith's Millinery & Fancy Goods. John and Emma Young had a store here by 1886 selling a wide variety of gifts. Emma was a great talker, and many Northporters came to her store to hear what she had to say, making the store one of the village's meeting spots. The wooden building was replaced by the current structure in 1925. First used as a Bohack's grocery store, it was the site of Bowman's Sporting Goods for half a century starting in 1953.

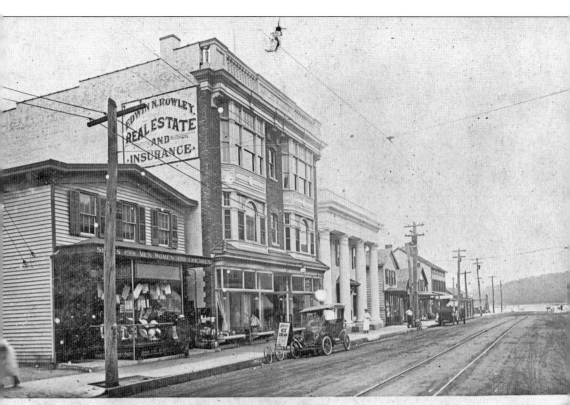

P2827 Rowley and First National Bank Buildings
Northport, L. I.

Edwin Rowley grew up on his uncle's farm in Sunken Meadow. He inherited the farm and worked the land until he came to Northport in 1907 and began a career as a real estate investor. He purchased this property, which included the Sammis & Oakley store shown in the Lange painting on page 72 and another building, from First National Bank of Northport in 1909. A separate deed created the passageway between the bank building and Rowley's building that is used today to access Sand City Brewery. This attractive mixed-use building was constructed at the same time as the bank next door. Rowley had his real estate office on the second floor. The smaller wooden building to the east was built for hotelkeeper Elkanah Soper in the 1850s. It has been home to a variety of enterprises over the years and has managed to retain its historic appearance.

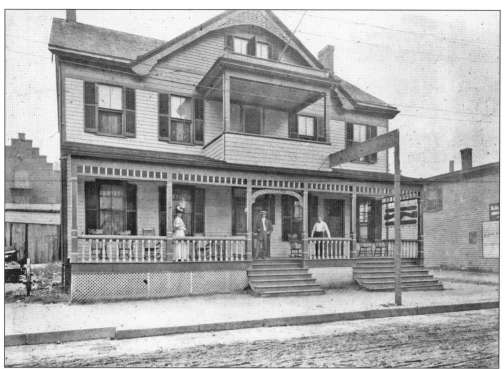

Originally known as the Hotel America and built in 1887 for Frederick Kathmann, who died two years later, this was the main hotel in Northport. A Mrs. Stevens purchased the hotel from William Call in 1892–1893 and changed the name to the Commercial Hotel. The hotel continued in business until 1921, when Giuseppe Cavagnaro purchased it and added a third floor and the brick facade. The storefronts in the middle and on the west side (which was added in 1923) have seen a variety of commercial uses. The east storefront was originally a grocery store. After Prohibition, Giuseppe Cavagnaro opened the Commercial Bar and Grill in the space. Peter Gunther purchased the bar in 1962. It became a favorite of Beat writer Jack Kerouac.

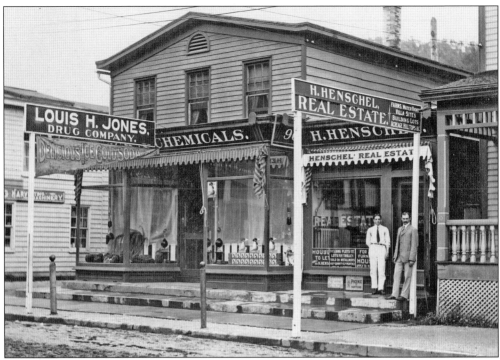

This is another survivor from the mid-19th century. Its earliest uses are unknown. In 1901, Louis H. Jones opened a drugstore here. Jones converted the small annex on the right, which had housed Harris Henschel's real estate office, into a soda fountain. Jones retired in 1958, but the new owners retained the name. Jones Drug Store moved across the street in 1971. This building has been used as a hardware store since, first as Eaton Hardware and now as Northport Hardware.

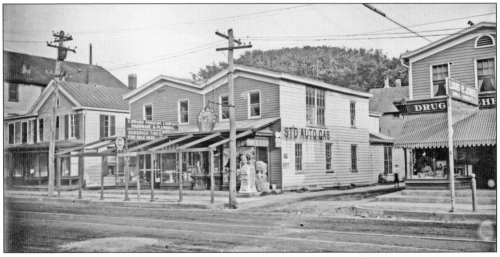

Tinsmith William H. Sammis, who would become Northport's first president, built this store in 1873. When Sammis died in 1903, Edward Pidgeon purchased the building and expanded its product line to include tools and other hardware. The hardware business continued here until Northport Hardware went out of business in 1965 and the building was demolished. The current building was constructed in 1971 for Jones Drug Store, and the Northport Hardware name was resurrected at the former location of Jones Drug Store.

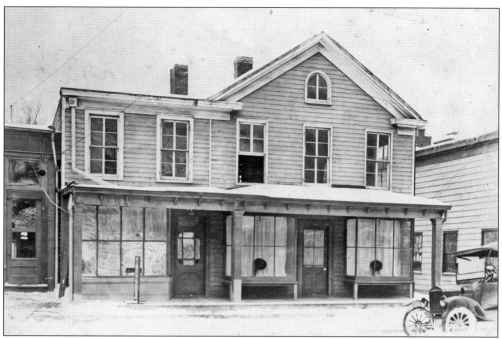

Grace Daniels operated a millinery store and cared for her blind father in her home (above). In January 1924, she attempted to extinguish a fire in the house without calling for help. She was badly burned and eventually was overcome by smoke. Passersby sounded the alarm, and her father was carried to safety at the rectory of Trinity Church. A week later, while recuperating at her brother's house, Grace jumped from a second-floor window, breaking both of her ankles and injuring her back. She died less than three months later at 47. The cause of death was not reported. The house was replaced in 1940 by this plain building that proudly displays its age.

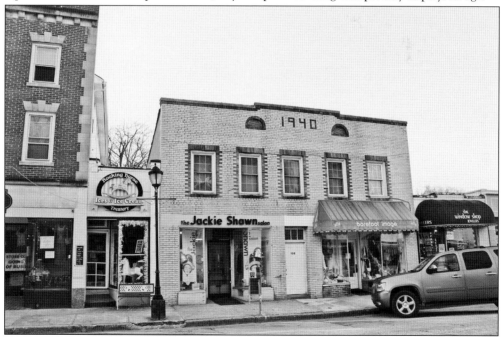

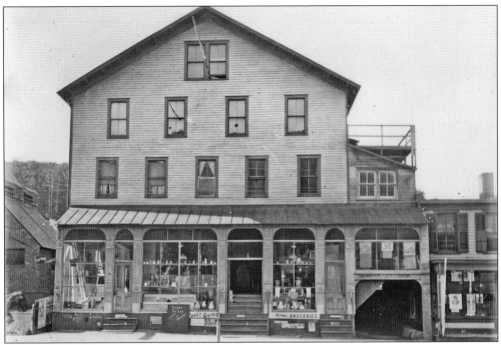

Phoebe Bonner, who sold household goods, had the store pictured above built in 1891. She ran a tearoom on the second floor. In 1906, the store was remodeled for the Saltz & Alter clothing store. In 1930, Saltz & Alter built a brick addition in front of the 1891 building and continued to operate their clothing store here. Traces of a display case for dresses sold inside can still be seen in the floor and ceiling in the building's recessed vestibule. One of the storefronts was the location of the state-funded Mayor's Committee on Unemployment Relief during the Great Depression.

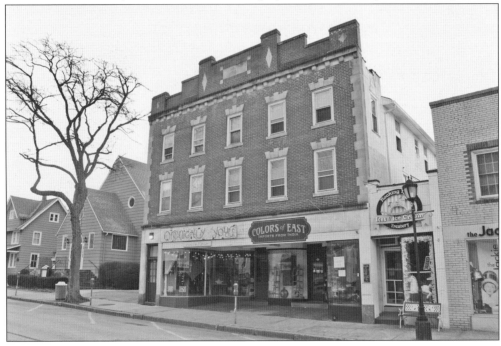

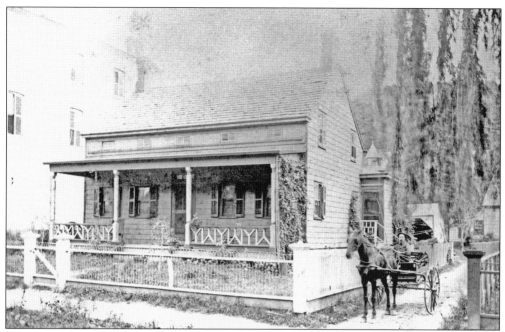

This is one of the oldest surviving buildings on Main Street. It dates to 1810 and originally stood where Trinity Church is today. It was moved in 1889 to make way for the church. Until 1845, Henry White lived here. White took advantage of the nearby springs to soak hides for tanning. The structure has been in commercial use since the 1930s.

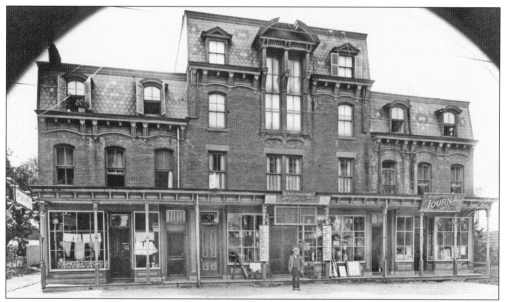

In 1875, Benjamin T. Robbins constructed this Second Empire–style building to house the offices of his newspaper, the *Suffolk County Journal*, which later became the *Northport Journal*. One of the first tenants in the new building was the local Masonic lodge, which purchased the building in 1916, shortly after Robbins died. The center and east side of the building were later extended toward the street, obscuring the original facade. The original mansard roof can still be seen above the storefront on the west side of the building.

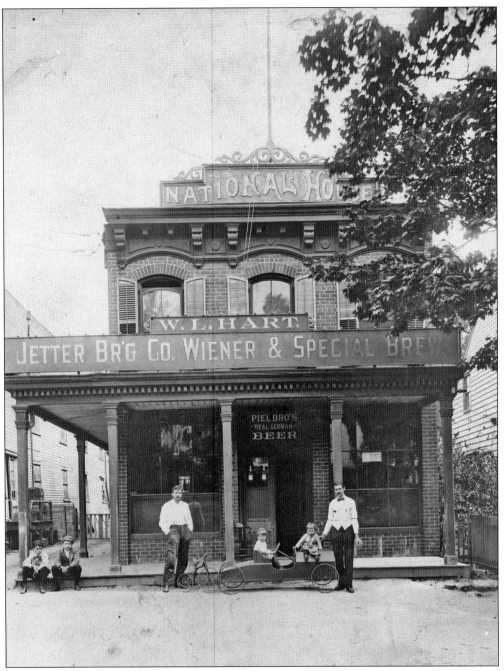

Benjamin T. Robbins also constructed this handsome building in the 1860s. It first served as a grocery store and later as a tavern and hotel known as the National House. The original cornice can still be seen beyond the one-story storefronts that were added in front of the building in the 1930s. The 19th-century building is now used for apartments.

Six

SERVICES

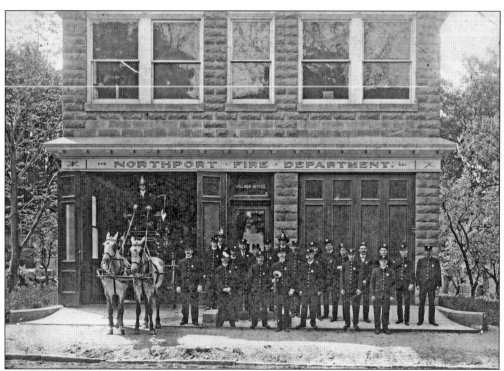

Members of the Northport Fire Department stand in front of the 1906 firehouse on Main Street. These men exemplify the community spirit that continues to thrive in the Northport community. From farmers and workmen who volunteered to help rescue mariners from shipwrecks until a professional lifesaving station was established to the men who marched off to war and returned to form fraternal organizations such as the Grand Army of the Republic and the American Legion, Northporters have always answered the call to service. They established the village institutions that make Northport the community it is: the fire department, the library, fraternal organizations, and the historical society, to name just a few.

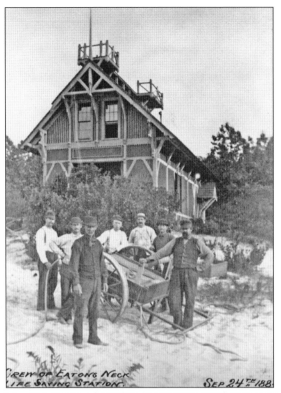

CREW OF EATONS NECK
LIFE SAVING STATION. SEP 24TH 188[?]

Even after a lighthouse was commissioned in 1799 (see page 13), the dangerous reef off Eaton's Neck continued to claim ships. Volunteers would assist the lighthouse keeper in rescuing crew members and passengers of wrecked ships. In 1849, merchants, ship owners, and underwriters formed the Life Saving Benevolent Association of New York to equip lifesaving stations. The first to be completed was down the hill from the Eaton's Neck Lighthouse. After the Civil War, Congress created the US Life-Saving Service, which professionalized the service. The first federal station in New York was completed at Eaton's Neck in 1876. The picture at left of the station house and crew was taken eight years later. Below are, from left to right, Jess Ketcham, a Mr. Russell, Capt. Henry Ketcham, Doug Lee, Vin Hartt, and Will Johnson. The Life-Saving Service was merged with the Revenue Cutter Service in 1915 to form the Coast Guard, which continues to operate from Eaton's Neck.

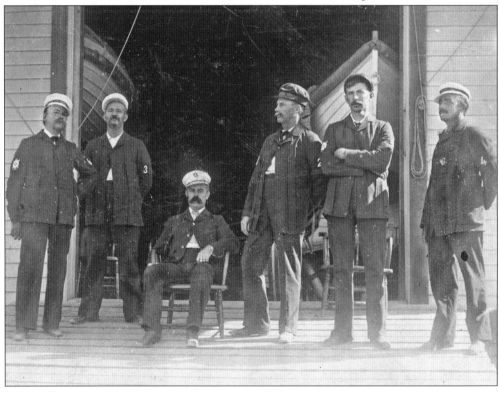

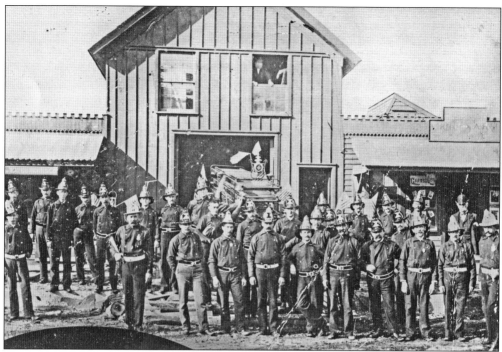

James Cockcroft, cofounder of the Edward Thompson Company, knew firsthand the devastation that could be caused by fire: he had lost everything he owned in the Great Chicago Fire of 1871. After the fire, he moved to Northport to take advantage of the quiet and fresh air. In September 1889, the three founders of the publishing company and 16 other prominent Northport businessmen met at the Thompson offices to form the Northport Hook and Ladder Company. Cockcroft donated a barn that was moved from Bayville Avenue to Woodbine Avenue, almost directly across the street from the newly built Thompson Building. When the village was incorporated in 1894, the fire department became a part of village government. The old barn soon proved to be too small to meet the fire department's needs. A new site was chosen on Main Street to house both the fire department and the village offices. The two-story building was completed in 1906.

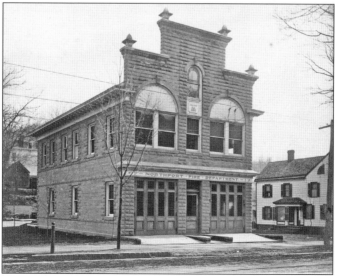

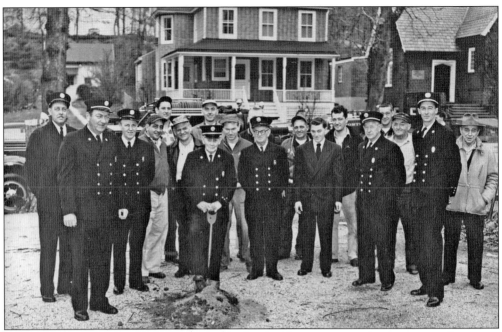

Within 50 years, the fire department again had to find larger quarters. In response to the urgent need for additional space, in 1950, the village purchased the house of Dr. DeWitt C. MacClymont next door to the west of the 1906 firehouse, and ground was broken for the new firehouse on December 6, 1953. The firemen moved to the new building, pictured below, in 1955. Fifty years later, the fire department again needed additional space, and after some controversy, the white building to the right of the firehouse was demolished to make room for an expanded firehouse and additional parking.

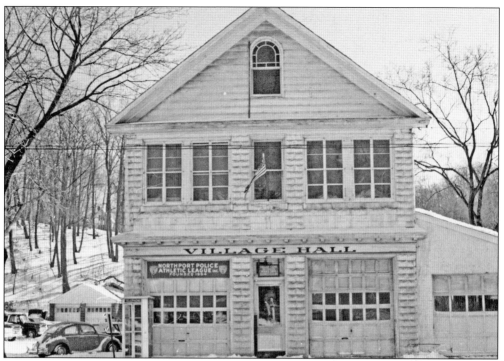

Village government continued to operate out of the 1906 firehouse after the fire department moved to larger quarters next door. The roofline of the building, above, had been changed. A dozen years after the fire department built a new home, it was decided that Northport needed a new village hall as well. The 1906 building was demolished in March 1968, a week before the LILCO power plant on Woodbine Avenue was dynamited (see page 36). During construction of the new hall, the village trustees met in the old library across the street. The new village hall, below, was dedicated on September 14, 1968, culminating a weeklong celebration of the 75th anniversary of Northport's incorporation as a village.

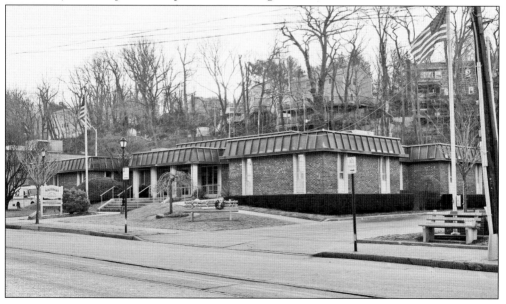

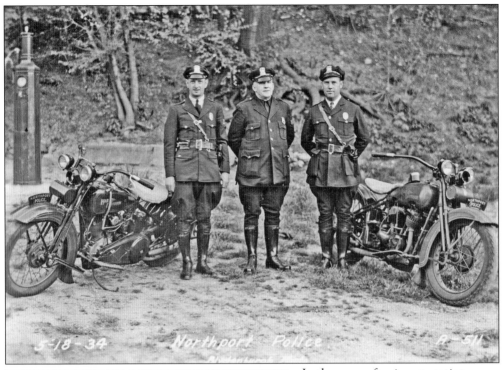

5-18-34 Northport Police A-511

NORTHPORT RESIDENTS

NOV. 5th YOU WILL HAVE THE OPPORTUNITY TO DECIDE IF THE VILLAGE OF NORTHPORT SHALL RETAIN ITS OWN POLICE DEPARTMENT OR TRANSFER ITS POLICE FUNCTIONS TO THE SUFFOLK COUNTY POLICE DEPARTMENT.

THE NORTHPORT POLICE BENEVOLENT ASSOCIATION

FEELS THAT A MO VE INTO THE COUNTY POLICE SYSTEM WILL BE ADVANTAGEOUS TO THE VILLAGE OF NORTHPORT AND TO THE MEN OF THE NORTHPORT POLICE DEPARTMENT.

THE P. B. A.
STRONGLY SUPPORTS
THE PROPOSED
MERGER.

THE NORTHPORT POLICE BENEVOLENT ASSOCIATION

In the years after incorporation, Northport retained the old system of electing constables. Slowly, a regular, salaried police force was established, initially focusing mainly on traffic issues. By the 1920s, the village police force consisted of a motorcycle officer, a traffic officer, and a night patrolman. Pictured here in 1934 are Officers Horace F. Allen, ? Johnson, and Charles E. Martin.

When the Suffolk County Police Department was formed in 1960, it absorbed the town police departments in the county's five western towns, including Huntington. Eight years later, a proposal to merge the Northport village police department into the county force was strongly supported by the Northport Police Benevolent Association. The proposed merger was projected to save village taxpayers $60,000 a year. Nonetheless, the proposal was defeated in a village referendum 1,365 to 925.

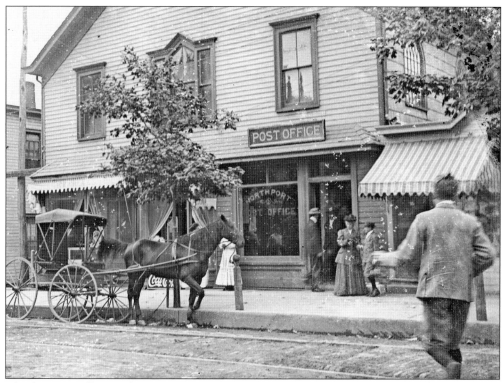

The first post office in the area was known as Crab Meadow and was established in 1820 in the general store of Charles Scudder at the northwest corner of Fort Salonga Road and Waterside Avenue. The post office relocated to the village in 1840, and the name was changed to Northport. As various postmasters were appointed, the office moved from location to location. In 1893, Charles T. Sammis was appointed postmaster, and he moved the post office to the old Presbyterian church on the west side of Woodbine Avenue south of Main Street, above (see page 94). The current post office was dedicated during a grand ceremony on Saturday, October 17, 1936, below. The building is listed in the National Register of Historic Places.

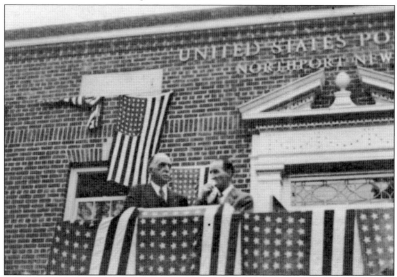

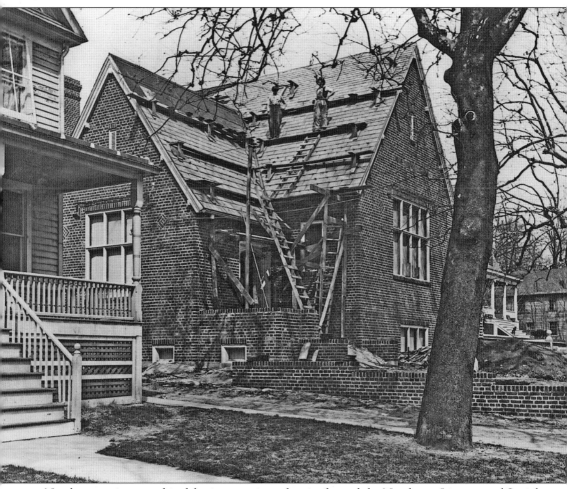

Northporters interested in debating a variety of topics formed the Northport Literary and Social Union in 1880. In order to prepare for the group's weekly debates, a library committee was formed to keep a collection of books. Interest in the library waned until a resolution to dissolve the group in 1907 instead reinvigorated it. Four years later, the union was recognized as a free public library, and in 1914, it received a charter as a public library. The question of a permanent home remained. Application was made to the Carnegie Corporation for $10,000 to construct a building. To meet the foundation's requirements, the library, primarily through the efforts of Amelia Brush, raised $3,000 to buy land at the corner of Main Street and Woodside Avenue. The library also secured the commitment of the village to raise $1,000 a year in tax revenue to operate the library. The new building opened on December 13, 1915.

With the postwar population growth, the library outgrew the old building, and it moved to larger space on Laurel Avenue in 1967. The Main Street building was used for offices. In 1974, village residents voted to sell the Carnegie building to the village, which in turn would lease it to the 12-year-old Northport Historical Society. The NHS hoped to raise funds to eventually purchase the building. That goal was realized much sooner than expected thanks to generous anonymous donors who purchased the building from the village and donated it to the NHS. Those donors turned out to be Stephen and Frank Cavagnaro (see page 124). The building was listed in the National Register of Historic Places in 1996.

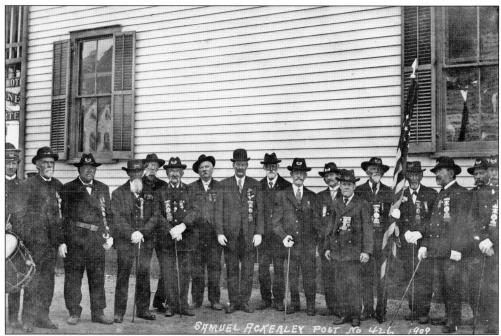

The Grand Army of the Republic (GAR) was the first truly national veterans' organization in the country. Chartered on November 17, 1883, the Samuel Ackerly Post No. 426 of Northport was named for the brother of founding member Nathaniel S. Ackerly. Samuel joined the 90th New York Infantry, Company I, early in the Civil War and lost his life a year later to yellow fever at Key West, Florida. Founding members also include Charles C. Fox, Jonas S. Higbee, and Alfred C. Tillotson. The Civil War Monument, which stands at the corner of Main and Church Streets, was unveiled on July 4, 1880. The Northport GAR was housed in various locations on Main Street until it was replaced by the American Legion after World War I. The American Legion Post No. 694 stands today on Woodside Avenue.

Seven

CHURCHES AND SCHOOLS

The 1870s saw the beginning of a building boom in the flourishing village of Northport. As the population increased, the need for more schools and churches was met by skilled builder Henry Scudder Sammis (1816–1897). "Boss Sammis" was known to have a large heart and to be generous to a fault. Henry, and later his son Charles T. Sammis, owned and operated a large coal and lumber business at the foot of Main Street and were Northport's preeminent builders for over 50 years.

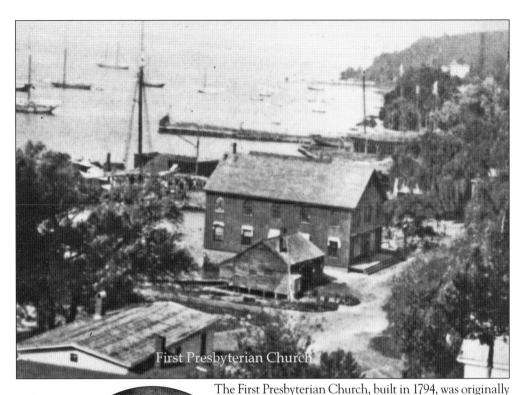

First Presbyterian Church

The First Presbyterian Church, built in 1794, was originally located at Fresh Pond on a knoll known as Meeting House Hill, which is now the northeast corner of Makamah Road and Route 25A. After the building was moved to the Red Hook area in 1829 to follow the population, a second story was added. The church building was sold to builder Henry Scudder Sammis in 1872 and later moved to Woodbine Avenue, as shown here. Despite efforts by residents to save Northport's oldest public building, it was razed in 1964.

The church at Fresh Pond was ministered on a part-time basis by Rev. Joshua Hartt (1738–1829). A Patriot during the Revolutionary War, Hartt gave fiery sermons against British rule. He became known as "the Marrying Minister" for officiating over 1,000 marriages. The Town of Huntington hired him to survey its shoreline and in doing so noted that the shore off Eaton's Neck was hazardous and suggested a lighthouse be built. (Courtesy of the Huntington Historical Society.)

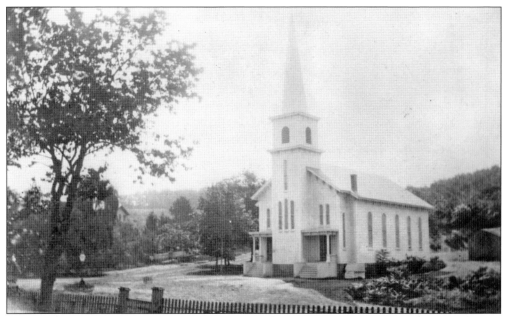

The new First Presbyterian Church of Northport was built in 1873 by Henry Scudder Sammis on land owned by Israel Carll. Sammis employed ship's carpenters, as evidenced by the use of masts for pillars in the basement. It still stands today on the corner of Church and Main Streets.

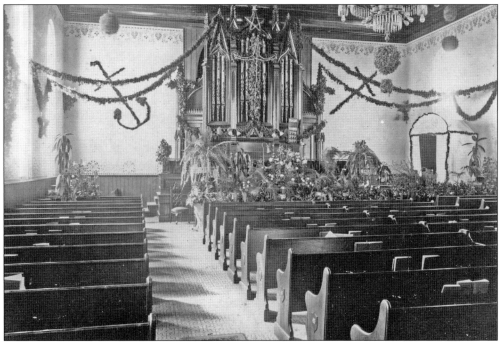

This photograph shows the First Presbyterian Church's interior around 1905. The decorations were called "Easter and the Empty Tomb" and were created by Elder Guy E. Johnston. The sanctuary was renovated in 1907, which included redecorating and new pew cushions. An extensive enlargement of the building in 1915 included the parish house, which housed the pastor's study and Sunday school rooms.

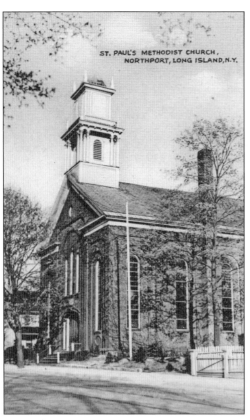

Northport village's first house of worship was a Methodist church built in 1834 on the corner of Woodbine Avenue and Route 25A. As the population continued to grow, a larger church became necessary. St. Paul's Methodist Episcopal Church, which stands at 270 Main Street, was designed and built by Benjamin T. Robbins and was dedicated with an impressive ceremony on August 24, 1873.

The interior of St. Paul's Methodist Episcopal Church is shown in 1885 decorated for Children's Day. Rev. C.W. Powell stands at the altar. Organist Vinie Brown stands up and to the right. An extensive remodeling of the sanctuary was done in 1932, which included a new organ, hardwood floors, and refinished pews.

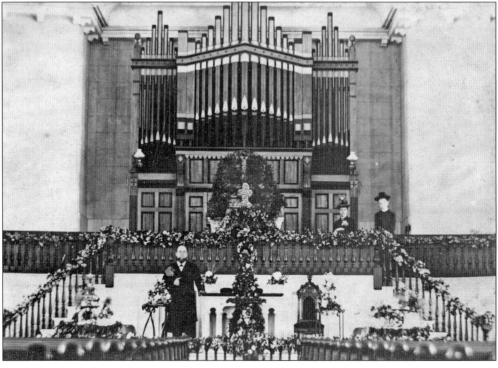

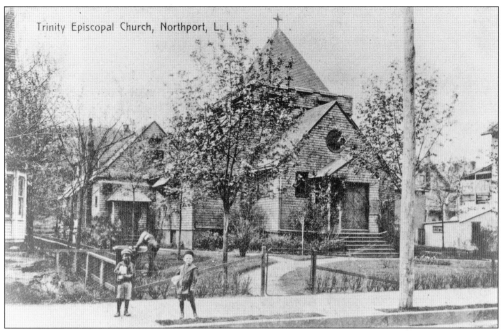

Trinity Episcopal Church, Northport, L. I.

Because of the steady influx of southern lawyers hired by Edward Thompson's law book publishing company, a meeting was held in the company's offices to form an Episcopal mission in Northport. In 1889, the cornerstone was set at 130 Main Street for Trinity Episcopal Church. The architecture was modeled after a church in rural England. Edward Thompson and his associate James Cockcroft, who had provided the lot, were both wardens. The boys pictured in this turn-of-the-century postcard are Tom Wood (left) and Leland Fox. They are holding packages of meat they were delivering for Leland's father, the butcher Mortimer Fox. Below, a group of young girls sits on the steps of the church around 1905.

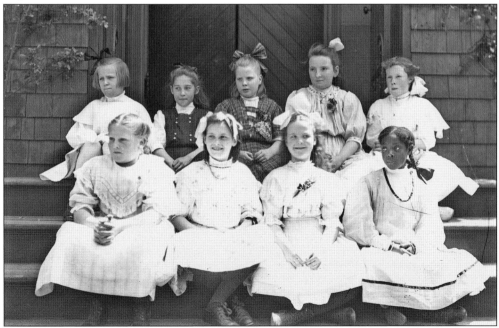

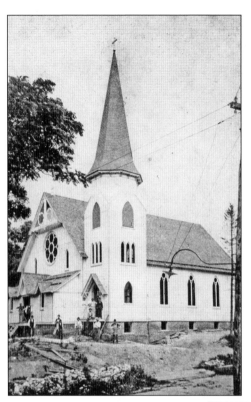

In 1894, Rev. Maurice Fitzgerald was appointed to establish a Catholic parish in Northport. The number of Catholics in the area had risen sharply due to the recent influx of Irish and Italian immigrants. In order to raise money for the construction of a church, local residents were asked to "buy a brick." Brick by brick, the foundation was laid at the corner of Main and Church Streets, and on September 9, 1894, the cornerstone was laid.

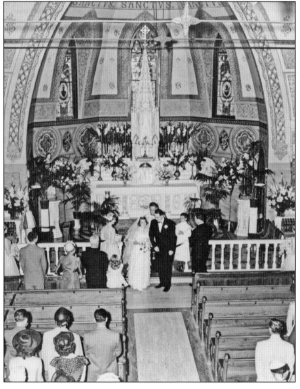

This 1952 wedding photograph of Kaye Smyth and John Duffy shows the beautiful decoration of the interior of St. Philip Neri. An unemployed artist from Greenlawn whose name has been lost to history adorned the church in exchange for room and board. The altar came from Star of the Sea Parish in Brooklyn. The stained-glass window in the center depicting Saint Philip was obscured by the steeple, which touched off a debate as to whether or not to lower it, but it remained as built.

In 1925, Rev. Ulick O'Sullivan Buckley revealed his hopes to build a Catholic school. A few weeks later, 30 one-thousand-dollar bills appeared on the desk of a village real estate agent for the purpose of acquiring the Edward Pidgeon estate, which was located just behind St. Philip Neri Church. The money was donated by Joseph T. Lilly, a shipping magnate who lived on Reservoir Avenue. St. Philip Neri Catholic School opened in September 1927. Today, it is called Trinity Regional School.

St. Philip Neri Church served for 75 years until it was demolished to build a larger church at the same location. The new brick church, built in the Colonial style, was dedicated on June 28, 1970. The pews of solid oak, set on a floor of terrazzo, provide seating for 900 people. The choir loft has ample room for a choir and organ, which was played by local schoolteacher Ella Sullivan (see page 103).

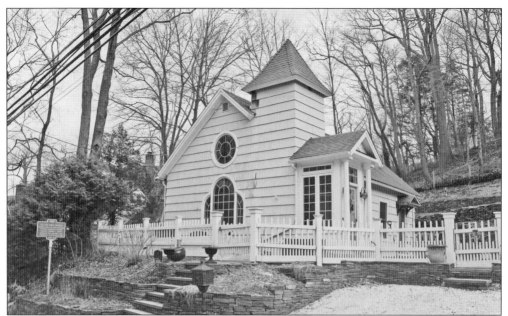

At the end of the 19th century, Northport's small African American population was primarily employed as chauffeurs, cooks, and gardeners. Faced with restrictions at other churches, they looked to build a church of their own. The African Methodist Episcopal (AME) mission struggled to raise funds. It managed to raise enough money to buy a parcel of land on Church Street and lay a foundation, but because it could not secure a loan, the project came to a halt. Then, real estate broker William Codling loaned the mission $500. On November 19, 1908, Allen AME Church was dedicated and the cornerstone was laid. Below is the Reverend W.R. Bayne, who served as pastor of the AME church in the 1920s.

Parishioners gather around Rev. Oliver B. Freeman next to the AME church in this photograph dated 1952. Due to the dwindling African American population, the church closed in 1967, but it still stands today as a private home at 54 Church Street.

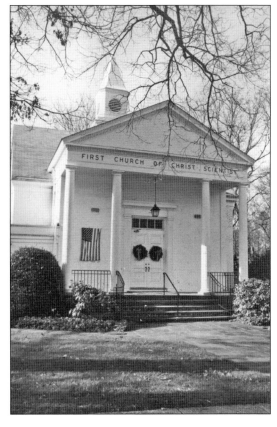

The Christian Science Society of Northport was organized around 1919 due largely to the efforts of John W. Dodge of Bayview Avenue. The society continued to grow, meeting in its hall on Main Street. In 1940, the First Church of Christ, Scientist, was formed, and on July 10, 1949, the first service was held in the newly constructed building on Laurel Avenue.

The oldest schoolhouse in Northport that still stands today in its original form is on Eaton's Neck Road. Known as School District No. 27, the school was built in 1822 to educate the children of the Gardiner family, who owned Eaton's Neck at the time. In 1823, ten children from the family attended. When the children completed their studies in the mid-1840s, the school was discontinued.

The Eaton's Neck school remained unused until 1869, when it reopened to accommodate the children of the many workers of the Beacon Farm and the sand mining companies on Eaton's Neck. Enrollment declined sharply after the turn of the century, and by 1922, with only four students, it merged with the newly formed School District No. 4.

102

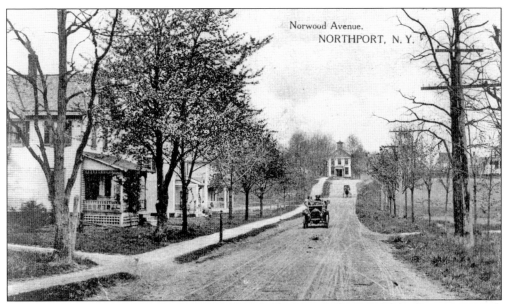

In order to build a new schoolhouse, shown in the far distance in this turn-of-the-century postcard, a new road, called Norwood Avenue, was laid connecting Main Street with Waterside Avenue. The school was built by Henry S. Sammis in 1875 to replace the old schoolhouse on Waterside Avenue, which burned down. This view is looking up Norwood Avenue from Main Street. The school still stands today as a private home.

Teacher Ella Sullivan (née Fealy) stands outside the Crab Meadow School with her class in 1917. She herself had attended the school as a child. She was brought to Northport at the age of three after her father, who worked on an oyster boat out of Connecticut, "discovered" Northport. Ella went on to teach at St. Philip Neri Catholic School for over 25 years.

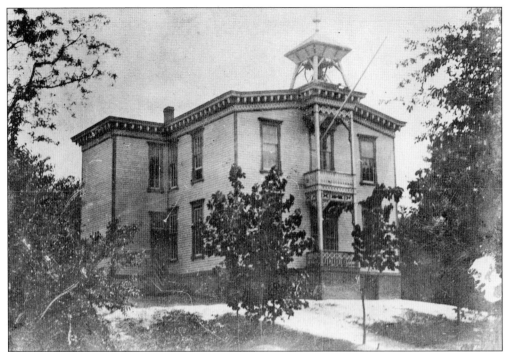

Prior to the early 1870s, two local school districts, Northport Harbor (District No. 7) and Northport (District No. 28), acted independently of each other. In 1872, these two districts merged, and the Northport Union Free School District No. 4 was established. The first public school in the newly formed District No. 4 was built that same year in Northport village. The new school was erected at the top of the hill on School Street, between Fox Lane and Scudder Avenue, overlooking Northport Harbor. It housed the entire body of students in six rooms that surrounded a central assembly hall.

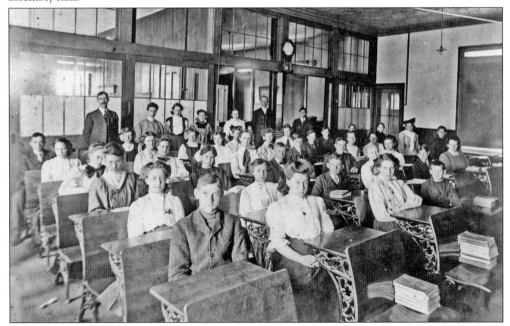

The new school served students only through the eighth grade. Students wishing to go to high school had to travel to Huntington. That changed in 1896, when the first high school department was established in Northport. The first graduating class of the new program entered the school in 1897 and graduated in 1900. There were only three students in the first graduating class: Amy Bialla (seated left), Lou Bouton (seated right), and Arthur Soper (standing).

On April 24, 1914, a group of over 200 local women met to nominate Georgiana Cockcroft (1872–1954) for a seat on the Northport Board of Education. She was elected as the first woman on the board by an overwhelming margin. In October 1915, she founded the Northport Parent-Teacher Association and served as its first president. During her tenure, she was instrumental in creating the first school cafeteria.

The Northport High School girls' basketball team of 1910 is just hanging out. Pictured from left to right are (below) Juliet Kenney, Effie Clerke, Vera Mott, Lorina Bishop, Irene Bennet, and unidentified; (in the tree) Phoebe Kingsley, Estella Quinlan, and Rhea Seymour.

The Northport High School boys' basketball team picture for 1920–1921 includes, from left to right, (first row) Edward Denham, Steve Cavagnaro, Frank Scudder, Tom Wood, and coach James Carter; (second row) Wade Lange and Harold Valentine. Wood was the first African American to play basketball for and graduate from Northport High School.

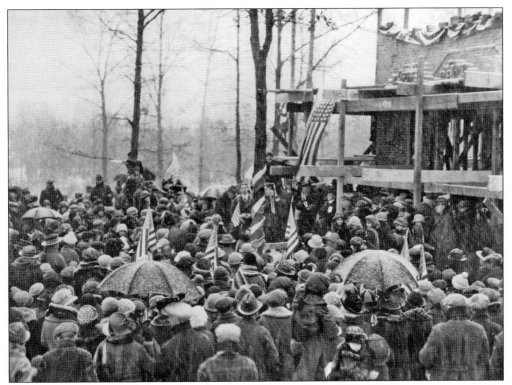

In 1922, board of education president Dr. Frank Quackenbush (1873–1938) was instrumental in closing the crowded School Street school and constructing a new, modern building on Laurel Avenue. On February 12, 1924, the cornerstone of the new Northport Union Free School was placed by Dr. Quackenbush.

Students came from Northport, East Northport, Commack, Eaton's Neck, and even Kings Park. Most walked; others came by trolley and train. There was one class and one teacher per grade, and the school day was six hours long. The school was designed to hold 500 students from elementary to high school.

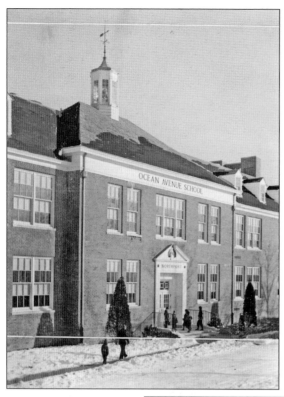

In 1933, the board of education sought federal funds to build a much-needed elementary school. The funding would provide community work opportunities, thus easing unemployment as well as overcrowding at Laurel Avenue. Ocean Avenue Elementary School was opened in 1938. The community enjoyed the outdoor ice-skating rink in the winter, and students enjoyed the shooting gallery in the basement, the library, and playing fields.

Florence Briggs began teaching third grade in the Northport–East Northport School District in 1928. She pioneered the use of puppetry in the schools in order to make education more interesting for her young students. Briggs also was a Sunday school teacher, a Girl Scout leader, and an officer of the PTA. After teaching at the Larkfield School and the Union Free School on Laurel Avenue, she eventually came to teach at Ocean Avenue when it opened in 1938. Florence Briggs retired in 1972 after almost 45 years of dedication to Northport's schools.

Eight

RECREATION

Water has always been central to Northport's existence, first as a source of income from shell fishing to shipbuilding and then as a place of recreation. One of the few areas of waterfront land retained in common ownership was at Crab Meadow, where Susan Sammis, mother of Cynthia Sammis Quackenbush, looks out over Long Island Sound. Picnic groves on Eaton's Neck attracted day-trippers from New York City who came by steamship to escape the city heat. Local and summer residents also banded together to form yacht clubs and golf clubs. Theater has also always had a place in the Northport scene, from the old Union Opera House to the summer stock stage at an old red barn to Broadway-quality shows at the Engeman Theatre. And, of course, Northport likes to celebrate itself every September with the annual Great Cow Harbor Day extravaganza.

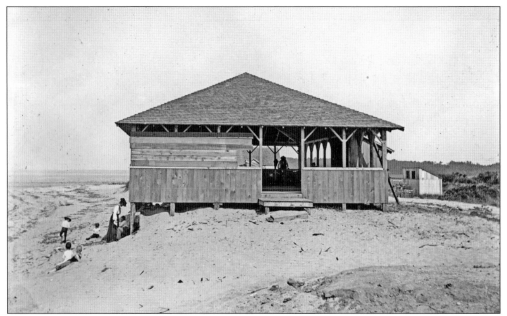

Although the town had owned the beachfront at Crab Meadow since the 1656 Eastern Purchase, no money was allocated to operate it as a public park until 1919, when residents voted to appropriate $5,000 for that purpose. Willis B. Burt, who operated this pavilion on land he owned between Waterside Avenue and the town beach, was hired to manage the public beach. In 1924, the town purchased Burt's property.

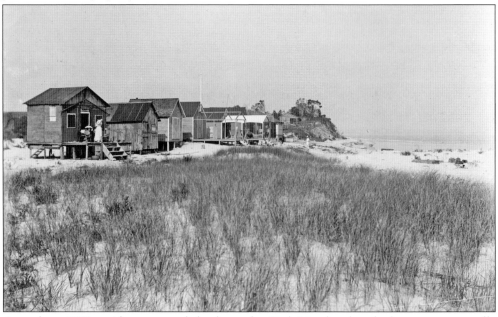

As early as 1901, residents erected shacks at the Crab Meadow beach that were reportedly constructed from shipping crates used by Thompson's publishing company. In 1907, residents of the area sent a petition to the town board requesting the town to remove the houses. It was not until 1919 that attorney Willard Baylis issued an opinion concluding that the people who built the shacks had no right to the beachfront.

In 1937, the old wooden pavilion was replaced with a Mediterranean-style brick-and-concrete building that featured locker rooms, showers, lavatories, a concession stand, and a rooftop sundeck. In front of the building, which was a WPA project, the town built an 18-foot-wide boardwalk extending 700 feet east and west of the pavilion. The new building was ready for the opening of the 1938 season.

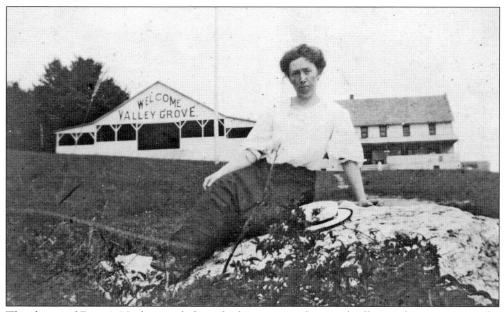

The shores of Eaton's Neck provided a refreshing respite for city dwellers seeking to escape the summer heat. Steamboats would ferry hundreds of picnickers to Locust Grove near the site of today's Hobart Beach. The fatal fire in 1904 on the steamship *General Slocum*, which was heading to Locust Grove, led to that picnic ground's demise. Its proprietor, Benjamin Mitchell, opened a new picnic ground nearby and named it Valley Grove. Pictured here is Anga Arthur, wife of onetime town supervisor John Arthur.

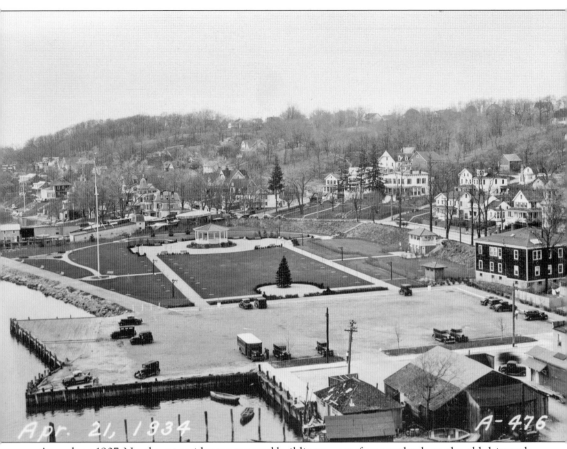

As early as 1907, Northport residents proposed building a waterfront park where the old shipyards had been located north of Main Street. It took another 20 years for concrete steps to be taken to make the park a reality. In 1927, the Huntington Board of Trustees agreed to lease its property along Main Street to the village, and the village issued bonds to purchase the shipyards of George E. Huntley and Henry Steers, formerly the Jesse Carll shipyard. The 750-foot-long stone bulkhead was built from rocks brought back to Northport by the Steers Sand and Gravel Company after delivering sand to New York City. Construction of the park proceeded slowly. Although the new bandstand was used in 1931, the formal dedication of the park did not take place until Memorial Day 1933.

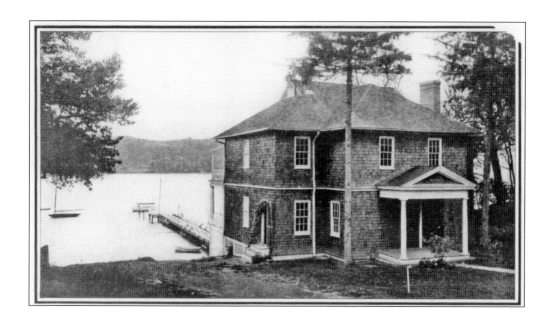

In September 1898, a group of Brooklynites with summer homes in Northport as well as several local residents met in the directors' room of the Northport Bank to discuss forming a yacht club. The club, with 56 charter members, received its charter the following April. At the same time, the club negotiated the purchase of a waterfront lot on Bayview Avenue opposite Stanton Street. The club moved the house that had been on the harbor across the street and completed the clubhouse pictured here in time for July 4, 1899. The members enjoyed the spacious porches overlooking the harbor.

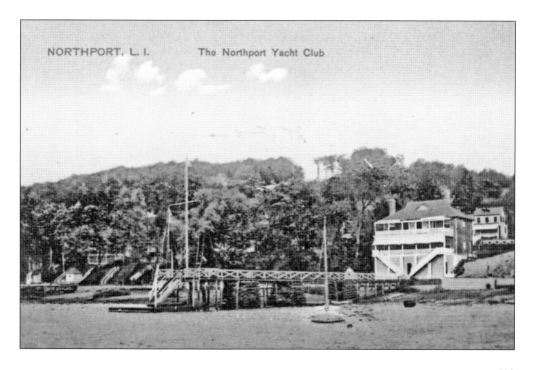

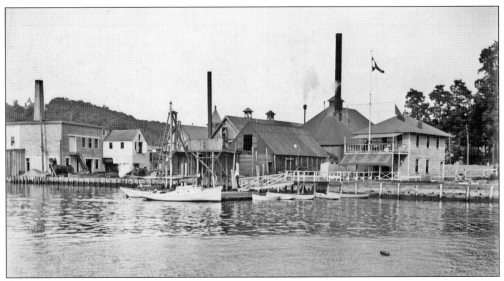

Shortly after the Northport Yacht Club opened its clubhouse, local residents formed the Independent Yacht Club with headquarters at Sammis's coal and wood offices on the harbor just south of Main Street. The clubhouse pictured above, next to the power plant, was replaced in 1910 with a larger clubhouse farther south at 137 Woodbine Avenue, pictured below. The two yacht clubs had a friendly rivalry over the next quarter century. The Northport Yacht Club did not open for the 1924 season. The following year, it was decided to cease operations, and the clubhouse property was sold at auction in 1925. The club had lost younger members to the Independent Club, and older members, who had started the club, took up golf at the newly formed Northport Country Club (see page 116).

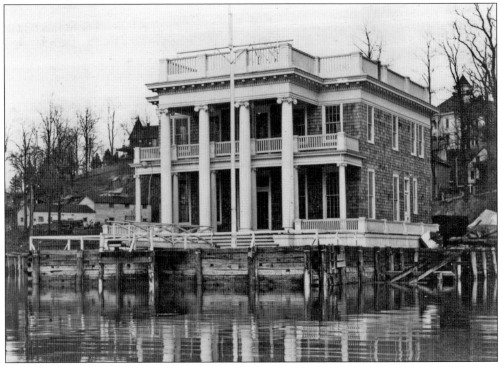

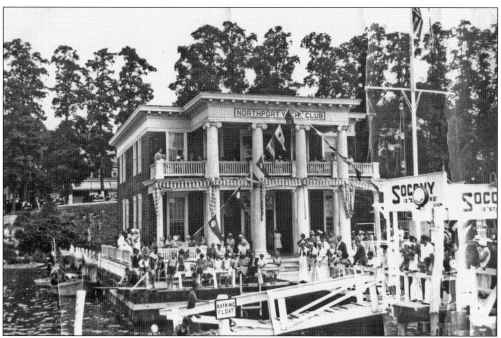

Shortly after the demise of the original Northport Yacht Club, the Independent Yacht Club adopted the first club's name, as can be seen in the photograph above. The club, however, was out of business by 1944, and its clubhouse was converted into apartments by Paul Kirchbaum. But a new yacht club was soon formed at the Edgewater Inn at the northern end of Bayview Avenue. The club took its name from the inn, and under the leadership of Benjamin Gambee, the Edgewater Yacht Club participated in races during the 1945 season. In 1946, the club purchased land from the Steers Sand and Gravel Company to build a clubhouse, below. The members built the clubhouse themselves. In 1952, the Edgewater changed its name to the Northport Yacht Club, and it continues to operate at Bluff Point.

THE GOLF LINKS AT THE NORTHPORT COUNTRY CLUB

The golf bug bit Northport's business community in the summer of 1923. Men such as Edwin Rowley, Henry Donnell, Henry Ingraham, and William Call formed the Northport Country Club and had a course laid out on the Edwin Brown property in Crab Meadow. The club did not last long. It was defunct by the 1940s, and the clubhouse, pictured here, burned to the ground in 1949. In September 1962, in a second attempt, Huntington voters overwhelmingly approved a referendum to acquire the former golf course and surrounding areas. The old course was refurbished and a new clubhouse built, and it reopened as a public course in September 1965.

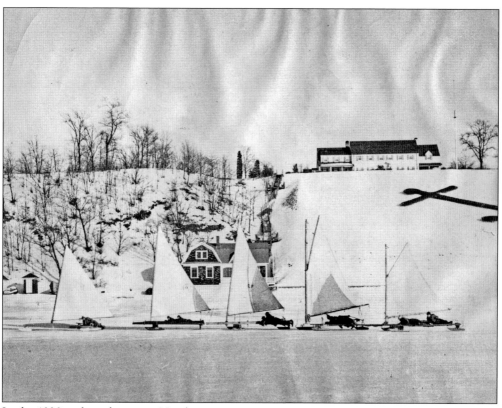

In the 1930s, when the ice on Northport Harbor was often as thick as a foot or more, local residents started an iceboating club. The boats would race over a three-mile course in as little as six minutes. Here, the iceboats glide past the Chesebrough estate on Northport Bay with its distinctive topiary hedge in the shape of an anchor. The hillside in this photograph would later be mined for sand (see page 33). Skaters also took to the ice and enjoyed bonfires on the frozen water as well.

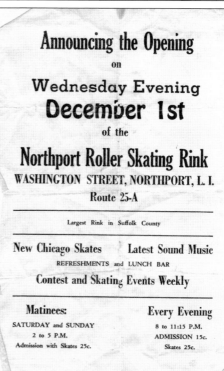

Announcing the Opening

on

Wednesday Evening

December 1st

of the

Northport Roller Skating Rink

WASHINGTON STREET, NORTHPORT, L. I.

Route 25-A

Largest Rink in Suffolk County

New Chicago Skates Latest Sound Music

REFRESHMENTS and LUNCH BAR

Contest and Skating Events Weekly

Matinees:	Every Evening
SATURDAY and SUNDAY	8 to 11:15 P.M.
2 to 5 P.M.	ADMISSION 15c.
Admission with Skates 25c.	Skates 25c.

Wednesday, December 1, 1937, was a big night in Northport with the opening of a new roller-skating rink. The land on Washington Street, now Fort Salonga Road, had previously been used for polo matches. The site is now home to a multisport venue with indoor courts and facilities.

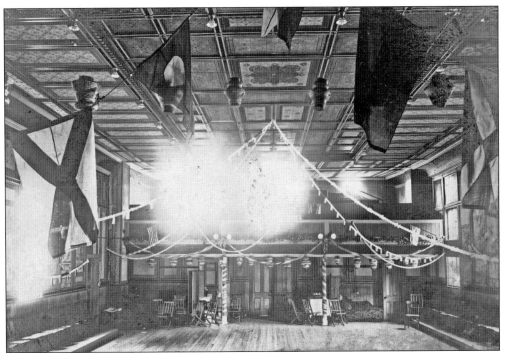

Builder and developer Benjamin T. Robbins opened the Union Opera House on the corner of Union Place and Scudder Avenue in September 1888. Most small villages of a certain size had an opera house that was used for a variety of performances and meetings but, despite the name, rarely for an opera. Pictured above is the interior of the opera house, which was considered "one of the finest halls on the island, outside of Brooklyn," according to the *Long-Islander* newspaper. The Union Opera House was also the venue for the first showing of a moving picture in Northport when *The Great Train Robbery* was shown in the early 1900s. By the 1920s, the building had been converted to industrial uses, first producing mah-jongg sets and later serving as a printing plant for the Hollis Press. Below, Northporters watch as the building is destroyed by fire in August 1926.

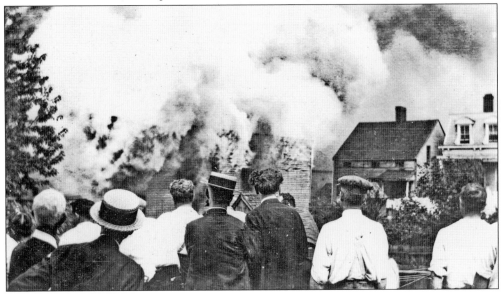

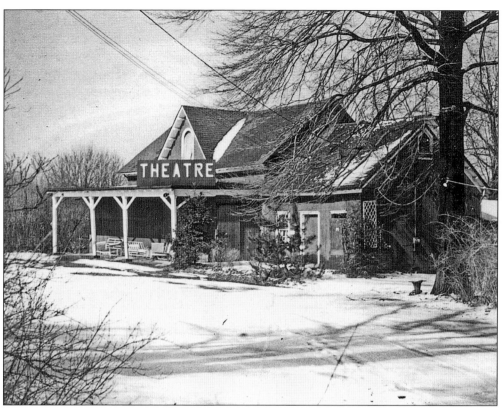

The old carriage house from the Scudder Homestead (see page 10), on Route 25A opposite Sandy Hollow Road, was converted into a summer stock theater in 1954. The 226-seat theater in the round featured professional actors, such as Phyllis Diller, as well as local students. The theater was destroyed by an early morning fire in April 1968, a year after New York State had acquired the property for a road-widening project.

The Northport Theater opened on November 23, 1932, with a screening of *Sherlock Holmes*. In 1950, the theater was extensively remodeled, including the installation of new seats, a modern air-conditioning system, and the stainless steel marquee seen here. By the 1980s, the theater was showing second-run movies at cut-rate prices. Attempts to revive the theater in the 1990s were unsuccessful. In 2006, Kevin and Patti O'Neill purchased the theater. In tribute to Patti's brother, who was killed in Iraq on May 14, 2006, the O'Neills renamed it the John W. Engeman Theater at Northport. After extensive renovations, the theater now presents Broadway-quality shows to the Long Island community.

To celebrate the community's history, the Northport Cultural Activities Committee organized a daylong celebration of Northport. Using the community's original name, Great Cow Harbor Day debuted in September 1972. A highlight of the day was the chance to view Dick Simpson's collection of 500 historic photographs. The day began with a parade and was capped off with a giant square dance at the foot of Main Street.

Crowds the first year were estimated at several hundred. By the second year, it was reported that thousands participated in the celebration of all things Northport. Now an estimated 25,000 people attend. The third edition of the day included a ribbon cutting of the Northport Historical Society's new museum in the old Carnegie library (see page 91).

In 1977, John Rakucewicz asked the organizers to include a 10-kilometer race the day before Great Cow Harbor Day. He was surprised to register 1,028 runners in the first year. Today, 5,000 runners race through the streets of Northport, cheered on by twice that many spectators. The Great Cow Harbor Day Race is now considered one of the top 100 races in the country.

From its inception and for many years, the Great Cow Harbor Day parade was led by Dr. Arthur W. Fredericks on horseback, accompanied by up to 30 hounds. Dr. Fredericks graduated from Cornell Veterinary School in 1931. He traveled from farm to farm to treat his patients before he established the North Shore Veterinary Hospital on Vernon Valley Road. He served as master and later master emeritus of the Smithtown Hunt for 25 years.

Nine

LASTING IMPRESSIONS

There are people in Northport's history who have made a lasting impression. One such person was photographer Frank Yamaki. After arriving in Northport from Japan, he purchased a photography studio on Woodbine Avenue. He became a popular man in town, photographing Northport and its residents. In 1905, he married Belle Pauline Brown, but four months later, Yamaki took his own life under mysterious circumstances. In 1979, his glass-plate negatives were discovered in an old barn by Stephen Cavagnaro, who made them available to the Northport Historical Society to make copies.

Italian immigrants Giuseppe and Anna Cavagnaro opened their grocery store on Main Street in 1904. Through hard work and a generous spirit, their family became one of Northport's most beloved and one of its largest benefactors. Their sons, Stephen and Frank, helped to build many of the storefronts on Main Street and owned and operated several businesses, such as a frozen food store, a restaurant, a liquor store, and a brickyard. The Cavagnaro brothers became some of Northport's largest property owners, known to hardly ever raise rents. The Cavagnaros loved to help those in need. They bought the organ for their church. They bought every policeman in the village bulletproof vests. When the NHS needed a building, Stephen and Frank bought the old library and donated it to the society in memory of their parents.

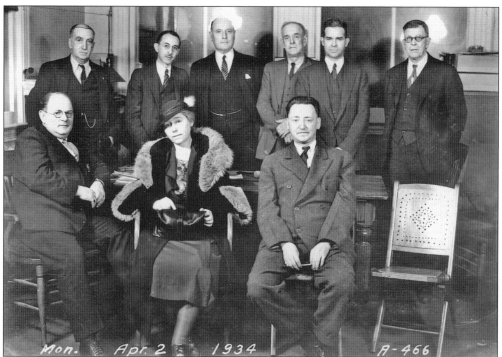

Mon. Apr. 2 1934 A-466

Marion H. Brett was the editor and publisher of the *Northport Journal* for 50 years, from 1922 to 1972. A widow who raised three daughters, Marion did her own writing, layout, and typesetting. She was a loyal watchdog, keeping Northport's citizens informed on all the important issues. She was a constant figure at village hall and board of education meetings. She is pictured seated with the village board of trustees. Trustee Henry Richardson (see page 126) is standing fifth from the left.

Cynthia Quackenbush Hendrie, daughter of Dr. Frank Quackenbush and Susan Sammis, was born in Northport in 1907. She trained as a dancer and opened a dancing school in Northport. Serving on many civic committees, Cynthia became an advocate for preserving Northport history. She was a founder, president, and trustee of the Northport Historical Society, was appointed village historian in 1962, and led the fight to preserve historic buildings.

125

WORK IN THE CITY
Play in NORTHPORT L.I.

PRODUCED FOR THE VILLAGE OF NORTHPORT BY FEDERAL ART PROJECT L.I. W.P.A.

In 1935, Henry F. Richardson, a village trustee, was appointed chairman of the Northport Development Committee. The Great Depression was taking a toll, and the committee was formed to explore ideas and secure funding to bring more industry, residents, and vacationers to Northport. Subcommittees headed by Marion Brett, Jesse Carll Jr., and Dexter Seymour developed plans to build an elementary school, enlarge the village dock, expand public beaches, and beautify the village park. Through advertising campaigns like this poster and special events, the committee was successful in creating jobs and stimulating business along Main Street to keep Northport families afloat when they needed it most. Richardson served as mayor from 1946 to 1953 and from 1955 to 1958. During this time, he worked to form a compromise between village residents who wanted sand mining to cease and the Steers Company, which wanted to expand operations. Richardson was able to get a guarantee that Steers would rehabilitate "the Pit" in exchange for allowing mining to continue along Ocean Avenue but stopping short of crossing it.

Robert Krueger was Northport–East Northport School District's first director of music education, serving from 1957 to 1982. Under his direction, the Northport High School marching band was the official band of New York State at the 1964 World's Fair. He was also the founder and director of the Northport Community Band and cofounded the Northport Music and Art Festival and the Powdered Wig Musical Society. Both the auditorium in the Northport High School and the bandstand in the Village Park are named in his honor. (Courtesy of Pam Dayton.)

Dolly and Ward Hooper shared their artistic talents and love of history with the community. Dolly owned an antique shop, Trolley Tracks, on Main Street in the 1970s and organized many community projects, such as Operation Santa. Dolly and Ward created the first exhibit for the opening of the Northport Historical Society Museum in 1974 and mounted exhibits for over 35 years along with past president of the Northport Historical Society Dick Simpson, seen here to the right honoring the Hoopers for their service. The Hoopers were instrumental in reactivating the Northport Chamber of Commerce. They also started Parlor Times, a monthly gathering of local artists, musicians, and poets.

DISCOVER THOUSANDS OF LOCAL HISTORY BOOKS FEATURING MILLIONS OF VINTAGE IMAGES

Arcadia Publishing, the leading local history publisher in the United States, is committed to making history accessible and meaningful through publishing books that celebrate and preserve the heritage of America's people and places.

Find more books like this at
www.arcadiapublishing.com

Search for your hometown history, your old stomping grounds, and even your favorite sports team.